In appreciation of your support for the Museum of Printing History

Dian Malouf

"The Printers Devil Caper"

Friday November 13, 1992

CATTLE KINGS OF
TEXAS

DIAN LEATHERBERRY MALOUF

Photographer
Author

JOHN B. CONNALLY

Introduction

PRINCIPIA GRAPHICA

Design

Beyond Words Publishing, Inc.

PUBLISHER
Beyond Words Publishing, Inc.
13950 NW Pumpkin Ridge Road
Hillsboro, Oregon 97123 USA

(503) 647-5109

DESIGN
Principia Graphica

PRINTING
Dynagraphics, Inc.

COLOR SEPARATIONS
Spectrum West

TYPOGRAPHY
Graphics Plus

BINDING
Hiller Industries

Other Books from Beyond Words

Within a Rainbowed Sea
Moloka'i: An Island in Time
The American Eagle
Wisdomkeepers
Light on the Land

Printed in the United States of America

Library of Congress Cataloging-in-Publication Data
Malouf, Dian Leatherberry, 1940-
 Cattle kings of Texas / photography and text, Dian Leatherberry Malouf ; introduction, John
Connally.
 p. cm.
 Includes bibliographical references.
 ISBN 0-941831-69-8
 1. Ranch life—Texas—History. 2. Ranch life—Texas—History—Pictorial works. 3. Ranchers—
Texas—History. 4. Ranchers—Texas—History—Pictorial works. 5. Cattle trade—Texas—History.
6. Cattle trade—Texas—History—Pictorial works. 7. Texas—Social life and customs. 8. Texas—
Social life and customs—Pictorial works. I. Title.
 F391.M25 1991
 976.4—dc20 91-73402
 CIP

This book is dedicated with affection to

DON MALOUF
My love, first and always

VIVIAN LEATHERBERRY SMITH
(1908-1989)

HENRY CLAY KOONTZ
(1934-1985)

PRESTON JONES
(1936-1979)

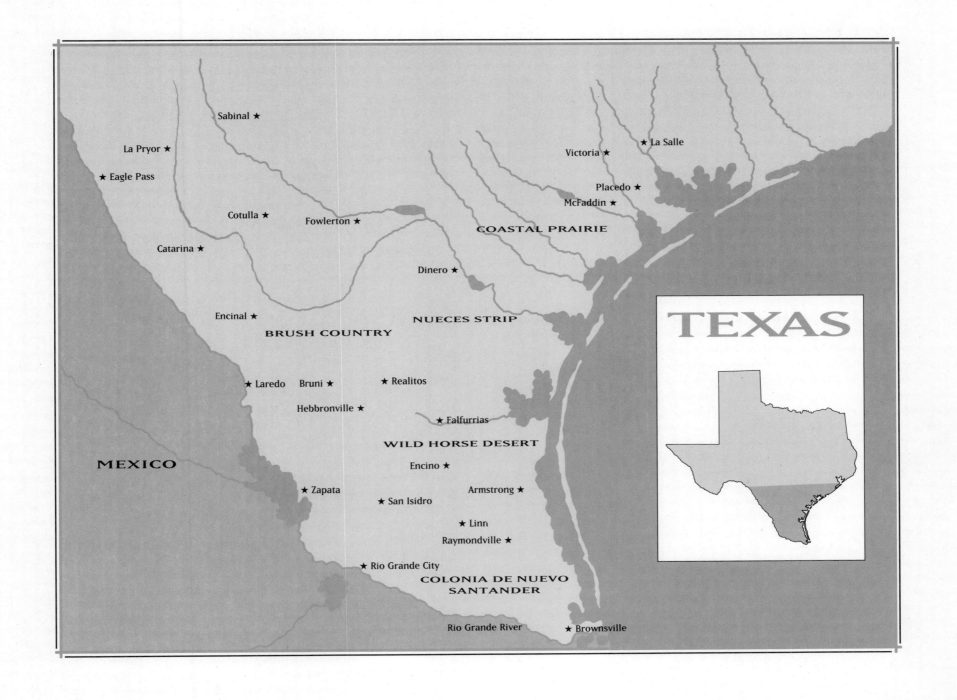

Sabinal ★

La Pryor ★

★ Eagle Pass

Cotulla ★ Fowlerton ★

Catarina ★

Dinero ★

Encinal ★

BRUSH COUNTRY

NUECES STRIP

Victoria ★ ★ La Salle

Placedo ★
McFaddin ★

COASTAL PRAIRIE

★ Laredo Bruni ★ ★ Realitos

Hebbronville ★

★ Falfurrias

WILD HORSE DESERT

Encino ★

Armstrong ★

MEXICO

★ Zapata

★ San Isidro

★ Linn
Raymondville ★

★ Rio Grande City

**COLONIA DE NUEVO
SANTANDER**

Rio Grande River ★ Brownsville

TEXAS

TABLE OF CONTENTS

INTRODUCTION

Dian Malouf's *Cattle Kings of Texas* is a fascinating story that will be enjoyed by everyone interested in the history of Texas and its development.

The author has written about real ranches and ranching in a vivid way. These vignettes of famous families tell of hardships, sacrifices, and struggles to overcome adversity; they show the ultimate love of the people for the land of their ancestors. Fierce pride of ownership is a common thread that weaves its way through the lives of all who are chronicled here.

The reader can relive the break of dawn, the squeak of leather, the pounding of horses' hoofs, the bawling of cattle, and the glories of the setting sun. All of these are a part of the hard work, love, and devotion to a way of life that fewer and fewer people experience today as the kaleidoscope of ranch life invariably changes.

Through the eyes of the author, the reader can glimpse a time, a place, and a way of life that is passing unheralded in the bustling evolution of our urban society.

Hon. John B. Connally, Jr.
Governor of Texas (1963-1969)
Houston, Texas
June 1991

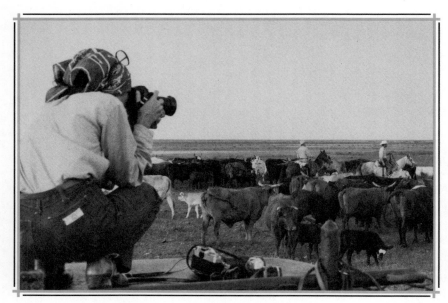

PHOTO BY JANE ALBRITTON

FOREWORD

Texas was never a refuge for the lowly or oppressed. Early settlers, says T. R. Fehrenbach, looked upon themselves as "a chosen race," as a collection of men who considered themselves morally superior, noble, and unafraid.

Among the earliest arrivals in Texas were the hot-blooded, difficult-to-govern, and iron-willed but loyal Scotch-Irish. They avoided existing civilization whenever they could, opting for the wide-open and empty space of a desolate frontier. Most were quiet men who preferred to stick to themselves. Involvement and participation were not in their character. Their only need for acceptance was internal—this has not changed. When the settling of the East, North, and West began, the Scotch-Irish headed to the last place left on the frontier—South Texas.

South of San Antonio, they tracked empty prairies, August sands, and a wasteland heaped with a cauldron of ominous names—the Wild Horse Desert, the Brush Country, and No Man's Land. Once a part of Mexico, this droughty frontier was a haven for outlaws, devil Comanches, and those who would resign themselves to a final settling, holding out long enough for civilization to dilute the country's treachery.

More than three million cattle roamed the open range of South Texas. It was easy for a man to build a herd. After the Civil War, the early cattle drives were the first effort to reunite the North and South. The trail drive was the genesis of a romantic era, one that would last 18 short years but remain a rite of passage emblazoned in the minds of the progeny of the men who took to the trail.

Steinbeck traveled with Charley; I traveled with a pistol.

In that raw, primitive country where the only concession to the twentieth century was a pickup and an occasional Dairy Queen, a .25-caliber pistol could come in handy. I have traveled more than 40,000 miles on a personal journey and preserved on film an intimate glimpse of a special breed of American whose life-style may be facing a final sunset. I crossed swift rivers, rounded up cattle on horseback, chased cows in helicopters, and took a boat to a remote island for a four-day roundup with 11 men and a camp cook. There was no running water or electricity. I dropped one of Nikon's best cameras in a heap of fresh manure while running away from a mangy one-eyed wild bull.

South Texas is changing, and soon the people who have defined its character will be gone. Unaccustomed to excess and studiously indifferent to the abundance of oil and gas that buoy up the cattle business, this breed will soon be only a memory to the next generation of Texans.

In this book I focus on some of the most remote and private ranching families in Texas. All are native individuals and historic survivors of this mystical country.

I have written this book for myself, for my family, and, I hope, for a country that can't help but be grateful for and amazed by Texans.

Dian Leatherberry Malouf
Native daughter
of the Brush Country

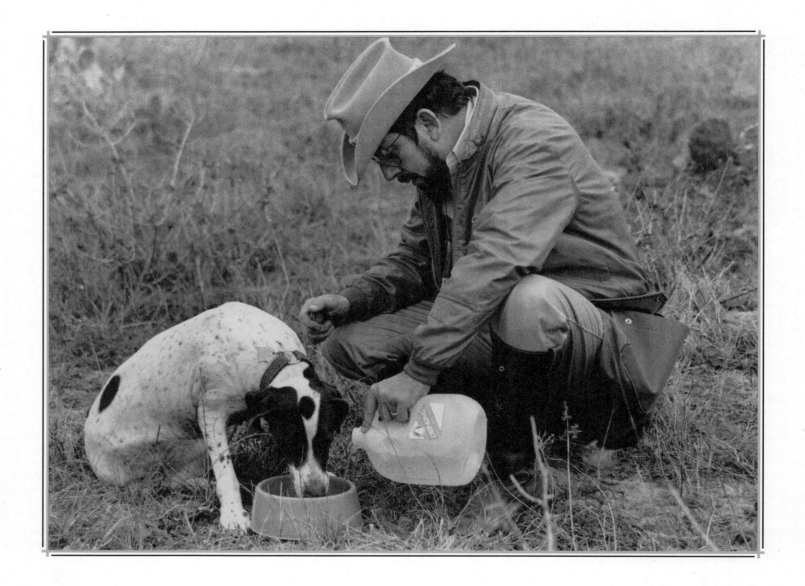

★ FAUSTO YTURRIA ★

"Sandra's a much better shot than I am. Do you realize how painful that is for me to admit?"

Fausto Yturria
Yturria Ranch
Near Raymondville

Fausto Yturria pulled up in front of the Harlingen Sheraton Inn looking more like a sophisticated prep-schooler than a rancher. Tied around his neck was a hot pink bandana that coordinated with his button-down madras shirt. Instead of Texas boots, he wore Gucci loafers.

Our only prior contact had been a series of phone calls and a battery of his predacious questions. After meeting at a designated place in Harlingen, we hopped into his monogrammed Mercedes and drove down the simmering blacktop road toward his ranch near Raymondville. I was soon to learn that he preferred jeeps to horses, wine to beer, and caviar to chili. He was born on Robert E. Lee's birthday and thought for a long time that the banks closed because it was *his* birthday. He is a practical joker, loves wildlife, dislikes snakes, and appreciates loyalty.

Fausto's grandfather, Daniel, was the adopted son of Don Francisco Yturria. Don Francisco was an educated man, fluent in both French and foresight. He owned the first bank south of San Antonio and made a fortune in banking just as Texas became independent. With banks in Brownsville, Texas, and Matamoros,

Mexico, Yturria provided a financial link between the two newly shaped republics.

In 1856, Don Francisco began purchasing land from the original San Juan de Carricitos grant, one of the largest grants given by the King of Spain. During the Civil War, he increased his fortune further. All Southern ports were blockaded by Union troops. The Confederacy depended on Europe for its guns and ammunition. The only loophole in the blockade was Matamoros, Mexico, and a small seaport near Brownsville called Bagdad, which has since been lost to a hurricane. When Southerners shipped their cotton via oxcart to Brownsville, Don Francisco acted as a middleman, arranging the sale of cotton in exchange for guns and ammunition to aid the Confederacy. The cotton was then loaded aboard the boats and transported to European markets. Don Francisco brought ready cash to the reconstruction and to himself. In 1865, he was knighted by Emperor Maximilian for his loyalty and support. Maximilian was so grateful that he further rewarded Yturria by making him chief of customs for all of northern Mexico.

An early incorporator of the St. Louis, Brownsville, and Mexico Railway, Don Francisco owned his own railroad car, which stopped near his ranch. A sign covering a platform near the railroad tracks not far from Fausto's ranch still reads YTURRIA.

"You know," said Fausto as we drove, "I can leave my office in Brownsville, and the expressway takes me right to the ranch gate in less than an hour. My dad told me that this same trip took all day when he would go to the ranch with his grandfather, Don Francisco, in a horse-drawn carriage. They would leave Brownsville early in the morning and go as far as the Arroyo Colorado River."

At Paseo Real, the early travelers crossed the river on a *chalan*, a kind of rope-drawn raft still used in Mexico. After crossing, they had lunch, refreshed the horses, and prepared for the second half of the trip.

Upon arriving at the Yturria Ranch, Fausto swapped the Guccis and the Mercedes for boots and a customized Volkswagen "Safari," built especially for hunting in South Texas. It was equipped to the hilt. We drove down to a picnic spot favored by Fausto and his wife, Sandra. Fausto pointed out a herd of unfamiliar animals prancing through the brush. "Those are Nilgai—Indian antelope—that weigh anywhere from 500 to 600 pounds," said Fausto. "They were brought over by Robert Kleberg and the King Ranch, I think in 1934."

"How did they get here?" I asked.

"Well," Fausto explained, "they jumped the fence and multiplied. You see, we're right next to the Norias division of the King Ranch."

The following afternoon in Brownsville I joined Fausto and Sandra for a pigeon shoot. Linda and Robert Montemayor greeted "armed" guests and lined up hunting paraphernalia against a

pier that overlooked a *resaca* (lake). Guns were lined up in the order in which the teams would shoot.

Fausto would shoot with the custom shotgun made for him by the Auguste Francotte Firearm Company of Liege, Belgium, the same company that made his great-grandfather, Don Francisco Yturria, a double-barrel, side-by-side shotgun in 1873. Fausto took his place on the platform built especially for skeet shooting and began to emcee the afternoon event.

He counseled Anne Armstrong a bit before she gave the order to the men below her on the platform. "Listo," Anne said. The men released the clay pigeon. Anne followed the clay pigeon with a quick half-swing and shattered the thing to smithereens in midair.

A year later I joined Fausto and Sandra at a hunt at their ranch honoring their friends Nancy and Nicholas Ruwe. Nick was former President Nixon's chief of protocol, and Nancy was formerly Betty Ford's secretary. Wildlife artist Peter Corbin was there also.

At 10:30 a.m. Sunday, I stepped off the plane in Harlingen looking like I was about to embark on an African safari without even darkening the doors of Abercrombie and Fitch. At noon, I pulled up in front of the ranch. A few minutes later, Sandra's parents, the Shelby Longorias, arrived. Then came the Ruwes (who had been not only to Abercrombie and Fitch but also to Purdy's), Peter Corbin, and family friend Tony Ortiz. Fausto, Sandra, and I headed for the picnic spot among the oaks.

When we arrived at the sheltered spot, Sandra spread out checkered tablecloths and glorious food. After several hours of exploring, lively conversation, and lunch, some of the group returned to the ranch for a siesta. Others chose to hunt under a threatening "blue norther" sky.

In a pasture not far away, Fausto spotted quail and

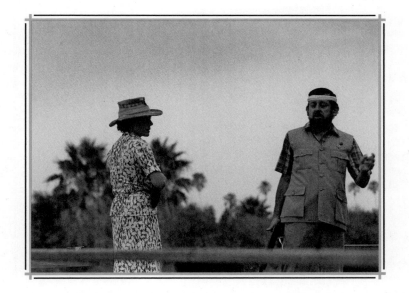

stopped the car. He, Nick, and Peter walked into the brush and stalked the covey. Fausto's brown-and-white bird dog made his way through the brush, oblivious to grass burrs and cactus. The men followed slowly and quietly behind. When the quail flew out of a clump of cactus, Nick took the shot. Each man kept his distance and offered appreciated safety.

Before returning to the ranch, Fausto stopped in the middle of a pasture and offered the hunters a flask containing gentlemen's sipping whiskey mixed with a variety of spices and citrus. Only he knew the secret ingredients. The contents of the flask warmed like a mesquite fire. We arrived at the ranch 30 minutes later and changed for dinner.

In the living room of the main house, Sandra had a huge fire burning in the fireplace. She sat at a nearby table and played backgammon with her son, Fausto III. Later she brought in a cauldron of caviar, and Fausto served Texas wine.

At dinner I asked Fausto the question that I had been dying to ask, hoping to satisfy years of curiosity once and for all. "Did they really fill the swimming pool with champagne when you and Sandra married?" I asked.

Fausto laughed and explained. "An [Associated Press] reporter had gotten wind that our wedding would cost in excess of $250,000. He was interviewing Sandra's mother, and in her haste she said, 'At the rate we are going, it will probably cost more than that!' The reporter turned it into an elaborate story and said that the swimming pool was filled with champagne. The real story is that the *wading pool* was filled with bottles of champagne that were iced down. In the big pool, we had papier-mâché replicas of a bride and groom floating in clouds created by dry ice."

After dinner, Fausto introduced a card game called Feliche Contento ("I am content"). I didn't know a jack from a paper clip. After an hour or so, I apologized for my lack of card knowledge and raked in the $26 pot.

When it was time for me to go, Fausto walked me to the car and said, "You know, Nick Ruwe and I have been friends for 25 years. I met him when I went to work in San Antonio for John Good's congressional campaign. I was in Washington when I served on the board of the public utilities for Brownsville, working on the feasibility of a salt-water conversion plant for the area. We went up to meet with the Department of Interior officials. The people with me hadn't seen the White House, so I said, 'Let's go over there.' Nick arranged it. We had a private tour of the White House. That was the day I sat in the president's chair, and guess what? The 'hotline' telephone in the Oval Office was not red, *it was green*!"

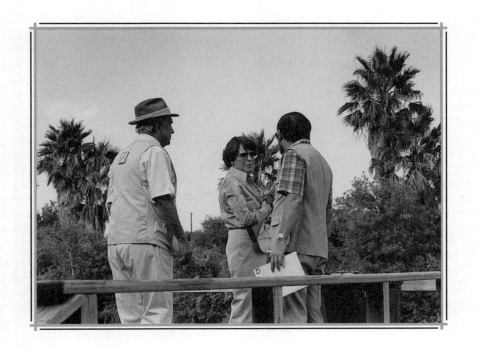

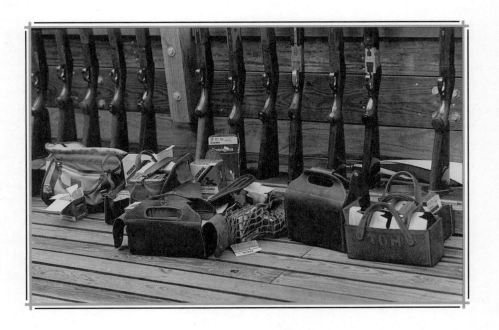

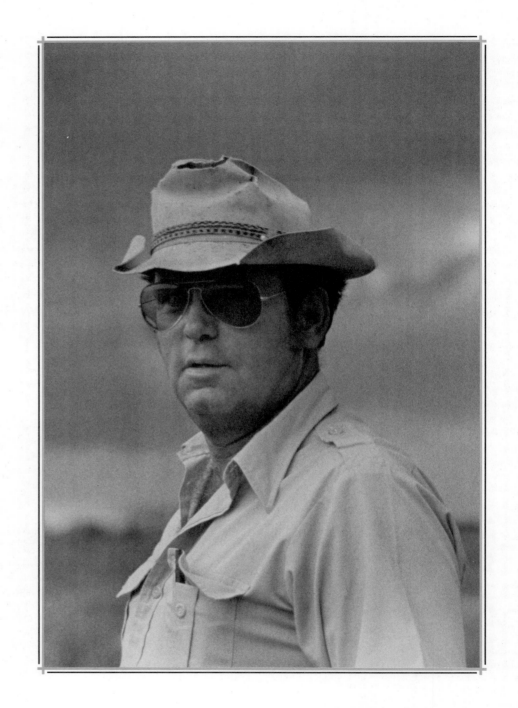

★ JIMMY McALLEN ★

"When I was a sassy little kid, some other sassy little upstart bragged to me about his family coming from the East with the Pilgrims. His other relatives came to Texas with Stephen F. Austin. I responded the way a kid would and said, 'Yeah, and when they finally got down here, my family was already here to meet them.'"

Jimmy McAllen
San Juanito Ranch/
McAllen Ranch
Near Linn

At an early age, Jimmy reflected the well-known McAllen independence, a commodity the family has never been short on. Jimmy's father, Argyle McAllen, refuses to set his watch to daylight-saving time. "The cows aren't on daylight-saving time. Why should we be?" says Argyle.

Argyle dresses in khaki cotton gabardine and tucks his pants in his boots. He looks like the type who would gladly strike out on a drive to Dodge City or repeat the single-handed stand that his father, James Ballí McAllen, made against Mexican bandits in a legendary 1915 shootout. McAllen won. Pocked with bullets, the house still stands.

The McAllen family predates Texas, mesquite, and stalwart male dominance. Jimmy McAllen's earliest ancestor, Juan Jose de Hinojosa, was a descendant of Spanish nobility. He left Spain in 1749, moving his family to the village of Camargo, nestled on the south banks of the Rio Grande River.

Jose de Escandon, colonizer of Nuevo Santander, appointed Hinojosa mayor of Reynosa, a village downriver from Camargo. In Reynosa, Hinojosa's daughter received an education

equal to her social position. Like most women of her era, she was trained in running a household and in instructing servants. Her fate, however, was not to be domestic.

Rosa's father had received a double portion of land south of the Rio Grande. His influence in government and his great personal wealth enabled him to procure vast amounts of land north of the Rio Grande.

In 1569, Jose Maria Ballí, a young and respected surveyor, came with his family to Mexico City from Salamanca, Spain. The Hinojosa and Ballí families were influential members of Escandon's colony. The families united when Jose Maria Ballí married Doña Rosa Maria. In 1774, captains Ballí and Hinojosa filed a joint application for the Llano Grande grant, pointing out to the Crown that it would benefit from the planned improvements, which included chapels that would convert and control wild Indians. Neither of them lived to see the grant through.

Following the death of her husband and father, and after a respectful year of darkened mourning, Doña Rosa Maria emerged, propelling herself from a life of comfort and privilege into a destiny that would buy her invulnerability in a society where a woman's validation was measured by the number of children she bore.

Rather than instructing servants in domestic chores, Doña Rosa Maria mounted her horse at dawn, spending the day riding horseback on her sterling-trimmed saddle and visiting her lands. Sixteen years later, Doña Rosa Maria's Llano Grande grant, one of the largest ever granted by the King of Spain, came to fruition. Among friends and in an ancient ritual of possession, Doña Rosa Maria celebrated her grant by pulling up herbs and grasses, breaking twigs, and tossing soil and water high into the four winds.

The strong-willed, independent Rosa then set about creating a ranching empire for her three sons. In the process she became the first "cattle queen" in Texas.

In addition to the 127,625-acre Llano Grande and the La Ferria grants, Rosa financed the Las Mestenas tract in the name of her brother. He, in turn, gave her 12 leagues of land, which she named Ojo de Agua. The city of Harlingen is located there today.

Perhaps the most important grant in the Ballí coffer was the massive San Salvador de Tule, consisting of 315,491 acres, or about one-quarter of the land in Hidalgo County, including the historical El Sal del Rey (The salt of the king). The land, excellent for ranching but not suitable for farming, was populated with herds of wild horses, tigers, lions, wolves, deer, antelopes, bears, and rabbits.

Rosa Maria's son, Padre Nicolas Ballí, and his nephew, Juan Jose Ballí, acquired the 154,280-acre Padre Island grant. The 117-mile-long island was known then as Isla Santiago. Tall dune grass nourished many of the cattle that were already there when the

priest-rancher arrived. Padre Ballí brought in the island's first settlers and built the first mission on the island for the settlers and for conversion of the Karankawa Indians. He called the settlement Rancho Santa Cruz. The area is now frequently referred to as the Lost City. Some of its ruins are still visible on South Padre Island. Padre Ballí died in 1816 of apoplexy and is buried near Matamoros.

Because of Doña Rosa Maria Hinojosa de Ballí's attention to detail, she ended up owning one-third of the lower Rio Grande Valley.

Fifty-eight years after Doña Rosa Maria festively celebrated her grant, and two years after the devastating potato famine that claimed 750,000 lives, John McAllen arrived at the Port of Matamoros by boat from Londonderry, Ireland. He was among the first American settlers in the lower Rio Grande Valley. Many of the men who settled on the cutting edge of the frontier were of Scotch-Irish heritage. They were loners, and that "stick-to-yourself" tendency is as prevalent among ranchers in South Texas today as it was 200 years ago.

McAllen met a Scotsman named John Young, who had a small mercantile store in Brownsville. The men became friends, and Young sought a location for a second store. Across from Reynosa, on the banks of the north side of the Rio Grande, a tiny village had grown around a mission founded by Escandon. Early colonists referred to the settlement as La Habitacion. It was later named Hidalgo, after Father Hidalgo, who led the 1810 revolution against Spain.

Young established a store there, hired McAllen, and changed the settlement's name to Edinburg in honor of his native Scotland. The two became partners in a steamboat venture, hauling hides, bones, and sugar to larger boats anchored at Bagdad and bound for European markets.

John Young married the feisty and active Salome Ballí. She, like her great-great-aunt, Doña Rosa Maria, took an active part in ranching matters. She and John, in order to secure ownership of the Santa Anita tract, began buying out heirs who had smaller ownerships in the grant. Together they built a productive ranch, running as many as 5,000 head of cattle. A son, John II, was soon born to the couple.

In 1859, John Young died, and several years later Doña Salome married her husband's business partner, John McAllen. When Father Parisot, an Oblate priest, wandered up to the remote Santa Anita Ranch and found an oasis of green trees and beautifully kept grounds, he said, "Civilization at last." Some of the other ranches he had visited apparently had been a bit on the primitive side.

In 1907, the Santa Anita tract was divided. John Young II was deeded part of the original grant, and the McAllens were deeded the San Juanito.

Barking dogs surrounded the car when I pulled up in front of Jimmy McAllen's attractive ranch house. Jimmy's young son, James, called the dogs by name. They quietly dispersed, following the little redheaded boy like obedient children.

Jimmy McAllen leaned tall and sturdy in the doorway. He greeted me with a hot cup of coffee and a tour of his home. There was a collection of antique colonial spurs that "came across" from Spain, and a collection of arrowheads. "I think all collectors have some yearning for the unknown. I see these arrowheads and think, 'Who made this, what was he like, where is he now?'"

In another room there was a collection of pioneer memorabilia and of Civil War artifacts that Jimmy had found.

"Everyone in my family has a hobby," said Jimmy. "My grandmother has a huge seashell collection. She is in her nineties, but she still goes to the beach and researches everything she finds. My mother writes family history and collects Texana, especially the Rio Grande Valley."

Jimmy and I climbed in his pickup and drove around the oldest ranch in Texas. He talked about how the whole thing got started. "I guess our ranching heritage began back farther than any other in Texas. The Spanish Ballí family received its grant from the King of Spain in 1791. The land has never passed outside the bounds of blood or marriage. Keeping the original parcel intact was no easy task, but we've increased it in size and productivity."

Before Jimmy had finished his last word, a minor territorial dispute arose when his father, Argyle, rode by on horseback, followed by a string of his vaqueros. He paused when he passed the truck and threw Jimmy a look vowing vengeance for wasting a perfectly good afternoon sitting in his truck talking to a woman.

Jimmy continued, "We're constantly improving our grazing lands, rotating our herds, and now I'm involved with a deer-conservation program. You know, everyone wants the big trophy. To stay in business today, we've got to be sure every acre of land produces something besides depletable oil and gas."

In a room that overlooked a swimming pool, Jimmy talked about his family. "In the '20s, people lived off the land. Hunting was not a sport, it was a necessity. Dad put a stop to hunting on the ranch. Our deer population naturally increased. Now we've gone one step further by breeding them up. We manipulate nature, but we make it better than it was. We are very involved with game management, and have hired a man to run our program who used to be with Texas A&M Wildlife Reserve."

Jimmy says that staying with a ranch this long is a matter of endurance. "You've got to tend the changes. Nothing natural stays the same, least of all the land."

For eight generations the McAllens have "tended the changes." They have survived bandits, droughts, depressions, hurri-

canes, epidemics of cattle disease, and interfering government. Their "don't-tread-on-me" attitude has helped keep their 70,000-acre ranch together. They plan to keep it that way.

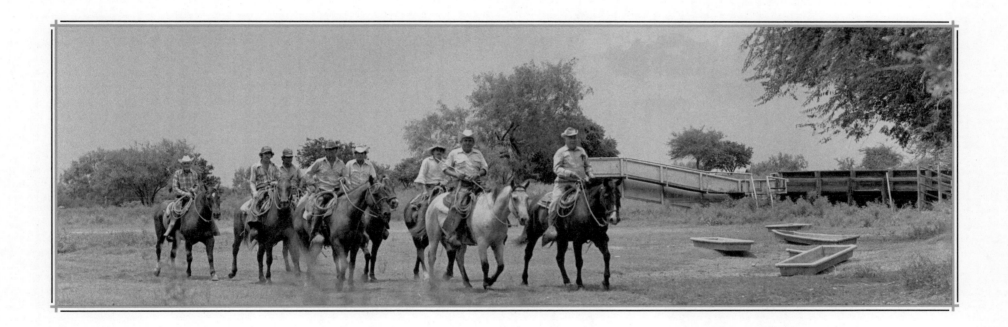

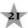

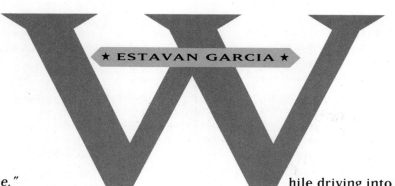

★ ESTAVAN GARCIA ★

"I didn't come to Texas. Texas came to me."

Estavan Garcia
(1886-1988)
Pacuvaya Ranch
Near Encino

While driving into Rio Grande City, I could not help but sense its historical past. What political upheavals or romantic liaisons were settled behind the shuttered windows of the ancient stone buildings that lined the town's main street? This distinguished old town on the banks of the silvery Rio Grande continues to cling to the symbols of nearby Mexico while languidly coexisting in the heart of the upwardly mobile Rio Grande Valley.

Once a part of Jose de Escandon's three-million-acre grant called Nuevo Santander, both Rio Grande City and Camargo played important parts in the settling of Texas. Camargo, located on the Mexican side of the river, was founded in 1749. Escandon, the colonizer responsible for settling many of the earliest towns along the Rio Grande, appointed Captain Blas Maria de la Garza Falcon as Captain of Camargo.

In 1767, with Escandon's permission, Captain Falcon established a ranch on the north side of the Rio Grande. Falcon named his ranch Carnestolendas, after an event like Mardi Gras celebrated in Andalusia, Spain, several days before Lent.

A few generations later, Maria de la Garza inherited

Carnestolendas. Maria married a soldier of fortune who had survived the Mier Expedition. His name was Henry Clay Davis. During the Texas Revolution, the ranch's name was changed to Rancho Davis. Davis built wharfs and established a shipping settlement on the river, and Rancho Davis became an important shipping stop on the Rio Grande for river freighters.

The town that embraces two cultures and shares a bridge with a sister city in Mexico still bears the name of the river that divides the two. A few blocks from the shuttered main street, Don Estavan Garcia opened the front door of his home and said, with the grand, sweeping gesture that jubilant Spaniards bring to life, "Welcome. Come in out of the heat."

I followed my aristocratic host, a descendant of one of Escandon's original colonial families, back through a cool room darkened by heavy curtains, to his study. The paneled room was filled to capacity with a gun collection that the Smithsonian would envy.

"You see," said Don Estavan, "in the Spanish tradition, the oldest son inherited all the firearms. My grandfather was the oldest, so he inherited four generations of Garcia guns. When my father died, I inherited all the firearms. Some of them are over 200 years old."

Included in the collection were sterling-silver Moorish spurs, his grandfather's cigarette lighter, a combination of flint and arrowheads, his father's gun emblazoned with a Mexican Eagle carved on mother-of-pearl and surrounded by gold chains, and a rare buffalo gun given to Don Estavan by Texas Ranger Frank Hammer.

Don Estavan sank back into the leather sofa and told of how his family inherited land in this state in 1740 through grants extended by the King of Spain.

"My family has been here before Texas existed. Then, the land was all prairie with tall grass and practically no trees. Since I've been around for a long time, people ask me what the old times were like.

"I was born in Camargo, Mexico, across from Rio Grande City, then known as Davis. Before ranches were established, Texas was just a large, vast prairie with hostile Indians. It was the custom of those living in Mexico to send their oldest son to Texas to take possession of the land grants. Two or three would travel together for protection and, when possible, would build together and not be in absolute solitude. Food was scarce. Corn had to be cooked first before making tortillas. That was a long procedure. I know, because I did it. In the winter, we kept a fire going outside all day long and through the night. We kept a tub filled with sand in the middle of the room. We'd bring hot coals in from the outside fire and drop them into the tub. This was our only source of heat besides our wood cookstove."

Don Estavan told of how a man delivered mail once a month on horseback. There were no newspapers; news came from travelers passing through. The children were taught at home by their parents.

"Later, my father employed a teacher with his own money to teach people who worked on the ranch," Don Estavan said. "The currency used was silver Mexican pesos, and no one wore blue jeans. Women made all the clothing, and men made the shoes. Men worked hard then, and women tended to the kitchen. You see, we had real women in those days." After a friendly altercation, the conversation continued. "My family has been in the cattle business for many years. In 1946 I was criticized for bringing cattle from Brazil through Mexico. I was accused of having perfected a black-market importation," he said. "The cattle had passed all inspections for hoof-and-mouth disease, but officials said my cattle were infected. They were the first new Brahma blood to be brought in in over 20 years. Cattlemen were excited. Their present stock was inbred. I brought in one Guzurat and a couple Gyr bulls.

"What saved me was a speech I made before a big crowd in Houston. I said my life's savings were invested in those cattle. I raised my hand and said, 'If I can be shown substantial evidence that my cattle are a menace to the cattle in America, I'll destroy my herd without cost to anybody.' That changed the tide.

"I was very fortunate," said Don Estavan. "My friends stood by me—the Storeys from Cotulla, the Gifford brothers, the McCans, the Joneses, and the King Ranch, to name a few. Mrs. Baker, Henry Clay Koontz's mother, went out of her way to support me. She wrote an article in my defense, against her lawyer's advice. She was a strong woman. She called me and said, 'Don Estavan, I'll be with you until hell freezes over.' We were friends for life."

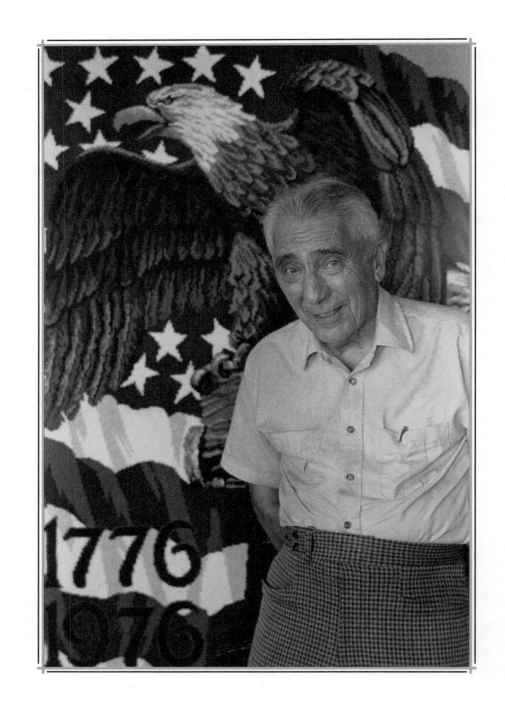

"I found Lon Hill once out hunting quail on our ranch. He had built a little fire in a clump of mesquite and was roasting a batch of quail on coals. He told me 'I can hunt anywhere I want, because I'm an Indian and Indians can hunt anywhere they want to in the United States.' I said, 'You don't hunt on my ranch without my permission.' Well, he left. I ran into him the next week and said, 'Lon, I've got a lot of quail out at the ranch. Why don't you go out there and kill a few?' He did, but his favorite place to hunt was some land he bought from Henrietta King for $2.50 an acre. That spot is now where the city of Harlingen is located."

J. A. Garcia
(1905-1985)
Santa Bertha Ranch
Near Raymondville

ut of Raymondville, the hermit *brazada* (brush) seemed inundated by the clout of a full and fervent sun. A long pale drought had turned Brush Country grass stalky and skeletal and the color of old parchment.

According to old-timers, this range country, covering thousands of acres, was once referred to as La Laguna del Perdido (The lake of the lost). Legend has it that if you got lost in this fearsome terrain, seldom did you make it out alive.

Because of Willacy County's proximity to the Gulf of Mexico, its coast was mapped by Alonso Alvarez de Piñeda, crossed by Cabeza de Vaca, and inhabited by Spanish colonizers as early as 1780.

Because Spain was eager to settle Texas and rid it of its native population, leagues of land were given to those brave enough to live on it.

Jose Narciso Cavazos, a Spaniard, showed outward disappointment when he did not receive the coveted Espirito Santo grant on the lower Rio Grande, on which the city of Brownsville sits today.

In order to console Don Cavazos, the King of Spain awarded him the 601,657-acre San Juan de Carricitos grant, the largest land grant ever given by the King. The survey of the grant began on July 4, 1790. The present-day Santa Bertha Ranch is in the center of the former half-million-acre land grant.

The July day was brain-frying hot. When I pulled up to the ranchhouse at Santa Bertha, the first thing I noticed was the aquamarine swimming pool. I reminded myself that I would ruin my cameras if I jumped in.

Inside the large den, Bertha and J. A. Garcia prepared for the annual Fourth of July picnic. Streamers, banners, stars, Americana, and other commitments to celebration were spread across the den. Teenaged grandchildren appeared and disappeared; each gave their grandfather a loving *abrazo* (hug) before leaving.

"The Fourth of July is a lucky day for us," said J. A., who was slightly bent by bone disease. He moved to a comfortable chair. "It's the day our grant started to be surveyed in 1790, which will make our ranch over 200 years old in the '90s. I don't think I'll be here for it, but...." His voiced trailed off.

"On the Catholic calendar, the Fourth of July is St. Bertha's Day, and since my wife—who is truly a saint—is named Bertha, that gives us another reason to celebrate."

The family had once considered naming the ranch Los Arrerros (The trail drivers), because the trail drivers on the Chisholm Trail used to drive their herds through the ranch and camp out in a heavily wooded pasture.

"There they were protected from the wind. I told my wife, 'We can call the ranch Los Arrerros or the Santa Bertha.' She got very quiet, so...," J. A. said laughingly, "you can guess what we named it. Those are a few reasons for our celebrating the Fourth.

"Our picnics, which we have every year, began when our ranch hands demonstrated their roping expertise for a few of our friends and relatives. Now we include people from all over South Texas, plus bishops, priests, politicians, and a few widows, who come here to feast on Texas's best barbecue with all the trimmings."

J. A.'s hand pointed toward a portrait over the fireplace. "The stately looking man in the portrait is my grandfather, Don Francisco Yturria. He made all this possible. He was wealthy beyond measure. He had bank accounts in Lisbon, London, Hamburg, New York, and Liverpool.

"Don Francisco, nicknamed Don Pancho, was born in Mexico. He married Felicitas Trevino. They adopted a son, Daniel, and a daughter, Isabel, my mother. Felicitas's family owned land in Hidalgo, Cameron, and Starr counties.

"Don Pancho was an educated man whose father was an army captain. He was very shrewd in money matters. He established the first bank south of San Antonio—in Brownsville, around 1853. He also had a bank in Matamoros.

"Brownsville boomed during the Civil War," said J. A.
"It was the most important seaport of the Confederacy. All other
southern seaports were blockaded by the Yankees. Brownsville
brokers merely took their cotton across the river to the Mexican
port of Bagdad. There they transferred their goods to European
ships, exchanging them for medical supplies, arms, and ammunition.

"You know," said J. A., "Don Pancho was one of the first
incorporators of the St. Louis, Brownsville, and Mexico Railway.
As a child I remember his arriving at the ranch riding in his own
private car."

Bertha Garcia was a soft-spoken Spanish *dama* with
beautiful skin and weighty opinions. She mentioned having the
cabana area around the pool glassed in because people used to
wake up and find rattlesnakes sleeping on top of their sleeping bags.

Bertha came to the ranch in 1923 as a young bride. "On
the first morning after our honeymoon, the camp cook barged
into our bedroom at 4 a.m., carrying a coffee pot and two tin cups,"
she recalled. Bertha suggested that the early-morning practice
be delayed at least until seven, and would he please mind
knocking first?

"I did not have to cook, then. The camp cook prepared
all our meals. We'd eat at the camp house, morning, noon, and night.
I wish we had it now!" she lamented.

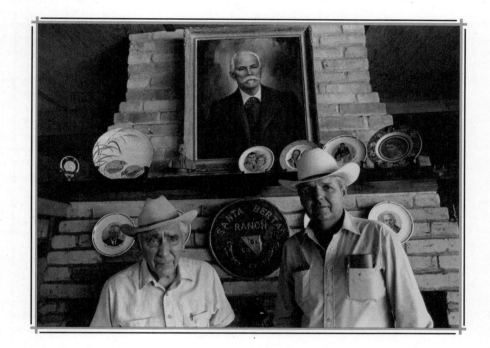

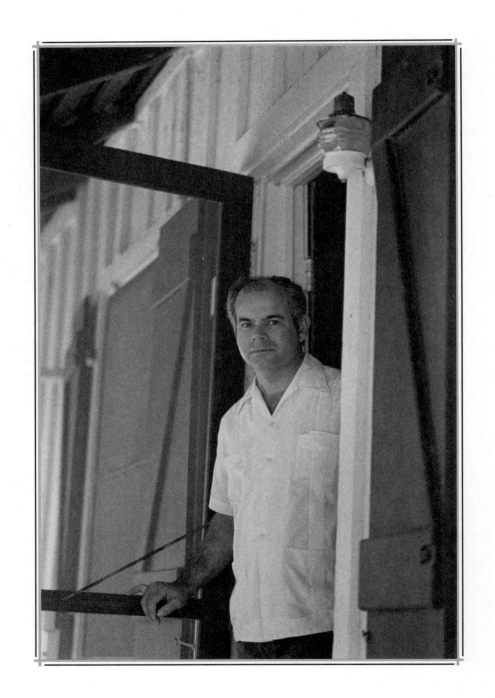

"The men on the ranch used to call me Niño Daniel...it's been a long time since anyone called me that."

Danny Yturria Butler
Punta del Monte Ranch
Near Raymondville

Unmistakably, the gracious entrance to the Punte del Monte (Point of the woods) Ranch signaled that beyond was a private and meticulously cared-for place with a turn-of-the-century past. Beyond, a pond mirrored clouds and sky. Cows wandered across a landscape of wildflowers and mesquite. The place was perfection.

Unseen assemblies raked and trimmed in rehearsed proficiency. Drifting in and out of the morning air, Mexican music competed with distant lawn mowers. A symphony of harmonic birds twiddled about in the branches of a giant old live oak tree near the Victorian house that had once been a stagecoach stop. The picturesque ranch seemed richly entwined in the combined lifestyles of nearby Mexico and the Old World. The mixture of the two created a vibrant, enchanting place that left me fraught with a tinge of envy.

Once part of the San Juan de Carricitos land grant, the ranch was founded by Don Francisco Yturria in 1858. Not far from the main house, his great-grandson, Danny Yturria Butler, sat at the rolltop desk where Don Francisco had paid the ranch help more than 133 years ago.

With a heightened sense of family awareness and a healthy respect for this historic ranch where his parents continue to live today, Danny pointed out an early printing press on which the ranch at one time printed its own newspaper. Danny's mother restored the office to its original condition, filling it with trappings from the Victorian period and a variety of memorabilia, including an August 1866 Brownsville newspaper. One side of the paper was in French, the other in English.

"There was a large French colony in Brownsville," said Danny, "and there was also quite a large number of Chinese.

"Francisco was so successful, he was knighted by Maximilian, the emperor of Mexico. No one knows why. He also helped the Confederacy by selling the cotton of Texas plantation owners. The Union found out and sentenced him in absentia. So, Francisco waited out the war in France. Eventually, he was pardoned by Andrew Jackson, and then returned from France to resume his banking business in Brownsville. He spent summers and weekends here," said Danny.

South Texas was a haven for outlaws and banditos, so Don Francisco built a 30-foot bell tower. A man stood guard from dawn to dusk, checking in all directions for unwanted arrivals. When a rider approached, they'd ring the bell. "There was plenty of time to give warning," said Danny, "it was a 'Sea of Grass' from here to Corpus. That's what the old-timers called it. Mesquite came in much later,

when cattle from Mexico came through. Wherever the cattle stopped, mesquite trees sprang up from their droppings."

Pointing to a frame building with a cross on top, Danny said, "Shirley and I were married out here. This was a church on Sundays and a school on weekdays."

Danny and I walked around the main house toward a series of well-used buildings that once were central to life on the ranch. Danny pointed out the general store. Next to the store was a building made entirely of vertical slats separated in the middle for ventilation. Ranch hands would hang freshly slaughtered animals to dry overnight. There was no refrigeration then, but the slats allowed the air to circulate around the fresh meat and keep it cool, and at the same time protect it from coons and coyotes.

A hardware store and a blacksmith shop also helped the ranch be self-contained, which was a necessity, not a luxury.

Today Danny works, as most ranchers do, to make ranching profitable. His concern now is less for self-sufficiency than for profitability. He rotates his cattle from pasture to pasture, conserving the grass so that it will not be overgrazed. Danny also explores every renewable resource on the ranch. Among his favorites is wild-game hunting.

"People come down here from Houston and Dallas to hunt javelina, duck, and geese. We provide a rustic hunting camp, serve them refried beans and tortillas in authentic surroundings; hunters

like the authentic—they don't want air-conditioned comforts.

"We work on every new management idea that comes along," said Danny, "but nothing will ever compare to the income from oil and gas."

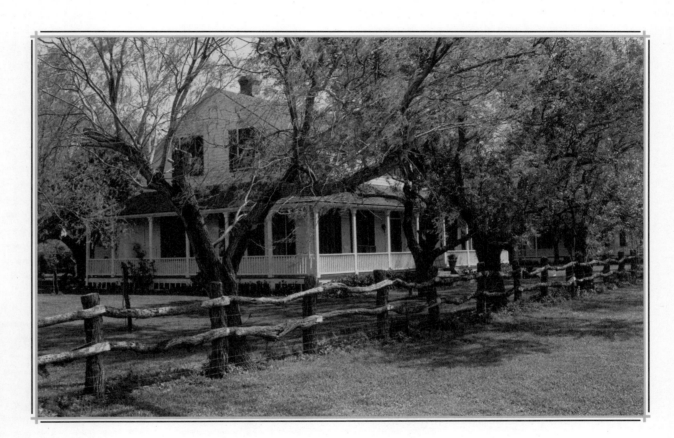

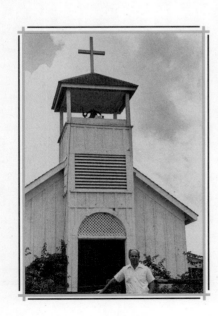

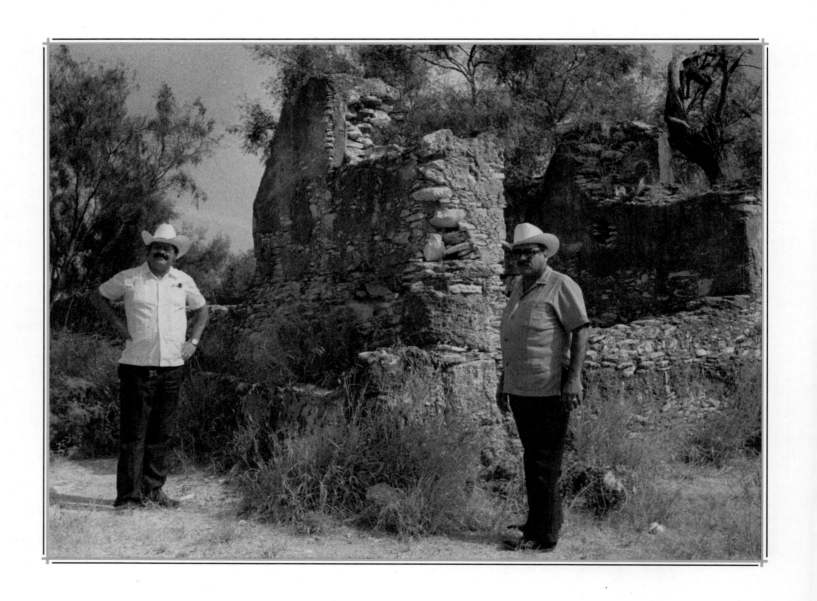

"When I was a kid, we'd work cattle with the cowboys. Sometimes there was no chuck wagon. We'd stick a tortilla in our chaps and that was it."

Tavo Perez
Rancho Viejo
Near Rio Grande City

"In the old days, on roundups, I'd stick a couple of tortillas in my chaps. That was my lunch."

Reynaldo Alaniz
San Marcos Ranch
and San Pedro Ranch
Near San Isidro

Reynaldo Alaniz and Tavo Perez are inseparable friends. One is a Republican, the other a Democrat. Both have ranches and both are from early Mexican families who had pioneered the Texas border country. Each likes to wheel and deal and, as they say, "work both sides of the street."

When I met Tavo and Rey in the lobby of the Fort Ringold Motel in Rio Grande City, the two men simultaneously removed their hats, as they have long been accustomed to doing. We exchanged weather reports—the obligatory conversation maker—and walked outside to Rey's car for a trip to their respective ranches. The morning heat had turned the parking lot into a series of tar puddles that did wonderful things to your shoes. As we pulled away from the parking lot of the motel, an old admonition popped into my mind: Daddy always said, "Dian, whatever you do, *stay out of Starr County.*"

When Rey's car turned north on the highway, I was fine, but when he turned right on a caliche road that wound through thick brush like a dying snake, Daddy's words stampeded through my brain like rotgut whiskey on an empty stomach. I reminded myself

that they had to be nice guys. After all, both were members of the Texas and Southwestern Cattle Raisers Association, and both, fortunately, were anointed in affability, likability, and talkability. Daddy, I think, would have approved.

In the early days, Starr County was a haven for outlaws and deserters. Long isolated stretches made it ideal for smugglers and bootleggers. That part may not have changed. Few discuss the conspicuously large homes scattered around the outskirts of Roma. Fewer discuss the source of funds that built them.

Many of Starr County's early settlers lived on the south side of the Rio Grande and grazed their cattle freely north of the river. Eventually the herds grew to such numbers that families crossed the Rio Grande and established ranches. Mexican cattle empires began, and Rey's family was among them.

Rey Alaniz is a fifth-generation Texan. "My family came here in 1864," he said. "My great-great-grandfather, Vicente Faiz, was granted land by the King of Spain. The land is still in the family. When I was a kid, I remember seeing 6,000 head of cattle on my Grandfather Albino's ranch, the San Pedro. It was open country, then," said Rey. "There were no fences, but the real demand was for sheep, horses, and mules—sheep and goats to eat, and mules to plow the fields for growing corn and beans."

The San Pedro was a family-owned hacienda. Every house had a thatched roof. The closest town, Rio Grande City, was 30 miles away.

"Every Saturday we would kill a fat cow. For a couple of days we had fresh meat, then we ate jerky. If you got tired of jerky, you'd have *cabrito* [goat]. That's why I don't eat meat anymore."

As Rey drove through the gates of the San Marcos Ranch, he mentioned that the ranch belonged to his wife, a Montolvo. Inside the house, Rey went straight to the kitchen sink, filled three glasses of water, and returned to the blue formica kitchen table. Ten to 15 yards from the window over the kitchen sink, seven visible oil wells pumped away. Rey rustled some papers from Sun Oil Company that were piled on the table, presumably the birth certificate of yet another oil well—number eight or possibly 208.

Tavo Perez's ranch has been in his family for four generations. Rancho Viejo (Old ranch) was a land grant from Spain. "My great-great-grandfather, Gregorio Perez, received the original grant," Tavo said. "Then it passed to my grandfather, Julian Perez, then my father, Hermin, now yours truly, Gustavo. My son, Gustavo, Jr., will be the fifth generation to own the ranch.

"We've kept it pretty much the same. It's all brush, but my son and I want to clear some of it and plant coastal bermuda."

Three times a week Tavo climbs in his "working horse" (a blue Lincoln Continental) and goes to the ranch and feeds the cattle from his rolled-down power window. "The cattle see my car

and chase me," Tavo said. "They know I'm bringing them food. Then I drive back to Rio Grande City. Usually I drive about a thousand miles a week."

In the late 1940s, when Tavo served in the Korean conflict, his mother made a novena to the shrine in San Juan de los Lagos in San Luis Potosi. She promised that if God returned Tavo safely, she would walk from her home to the shrine on her knees. Tavo returned home intact, and his mother fulfilled her promise.

Rey's mother's ranch, now modernized, was part of the old hacienda. "I'd love to visit with your mother," I said. "Well," said Rey, "you can't. The lady doesn't speak a word of English."

While driving back to Rio Grande City, Rey recalled what South Texas was like during Prohibition.

"There was this *tequilero*—a man who brought in rum and tequila on a pack mule from Mexico—who always came to our ranch and traded his tired horse for a fresh one. He always left two large bottles of tequila for Dad every time he came by. His name was Severo Olivarez. He was later shot by the Texas Rangers—*Los Diablos Tejanos* [The Texas devils], as some people called them."

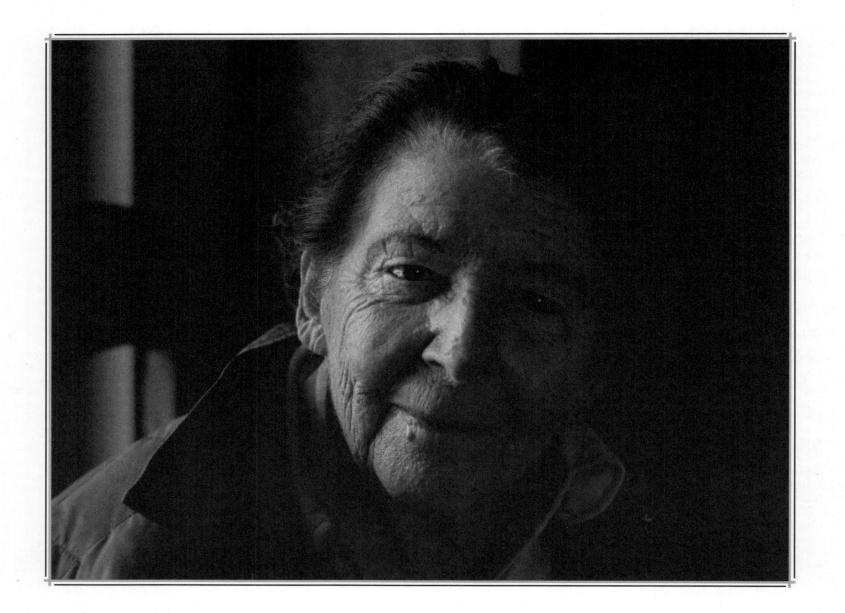

**Alice Gertrudis
Kleberg East**
Granddaughter of
Captain Richard King

San Antonio Viejo Ranch
Near the Rio Grande River

Burdens of convenience and the disruptive loss that change often brings stop abruptly at the entrance of the 350,000-acre San Antonio Viejo Ranch, 13 miles north of the Rio Grande River near Zapata. Beyond the well-guarded gates, miles from the main road, Alice Gertrudis Kleberg East lives in a small and sequestered gray cinder-block ranch house. With the exception of electricity, suggestions of modern conveniences are moderately few.

In the last 90 years of her unchronicled life, Alice has proved herself a fierce independent and a historic survivor of the old school. When Pancho Villa's banditos raided the ranch and tied her up, she managed to tuck her boots under her and sit up all night hiding her brand-new sterling-silver spurs from the bandits in case they reappeared.

There were other invasions. Beginning in the '30s, enough oil was found on the East ranch to warm the Eastern populace for the next 20 years. To Alice, the coming and going of drilling crews was nothing but a bother and, frankly, not worth disrupting the cattle. Her spartan and simple life remained disproportionately unchanged.

The wealthy isolationist woman stood with her back turned to the fireplace. Her daughter Lica stood next to her with her hands extended toward the heat of the fire. Both women wore heavy down jackets and blue jeans. The slight heat from the fireplace was the only heat in the house. On the fireplace mantel was a collection of familiar photographs, the only suggestion of aristocracy. Alice bears a striking resemblance to her grandfather, the late Captain Richard King, a former riverboat captain who freighted goods up and down the Rio Grande River, loaned money, and acquired land that became the internationally known fiefdom of the King Ranch, which survived droughts, reversals in the cattle markets, and land and mineral dispersions, mainly because of generations of offspring dedicated to a powerful family cohesiveness.

Next to the photograph of King is a portrait of the Kleberg family. The subjects' eyes are focused directly on the camera—all but Alice's. Hers, charged with coyish rebellion, look the other way. Her life has followed suit.

Alice spent her early childhood in a large frame house in Corpus Christi that she refers to as "Mama's House"—the one that burned. Later she moved to the main house at the King Ranch, which had enough rooms for each of the five children to raise their families. This showplace on the banks of Santa Gertrudis Creek had Tiffany windows, tiled fountains, and fern-filled courtyards where peacocks roamed freely. It was much too civilized for Alice.

After the death of Henrietta King, her daughter and son-in-law inherited more than 800,000 acres. In 1934, they and their five children incorporated as the King Ranch. The family pledge was to stay together for 20 years.

In the '50s, the corporation dissolved. Alice gave up her royalty interest in the King Ranch for the San Antonio Viejo and Sante Fe ranches. The San Antonio Viejo had belonged to her husband, Tom, until 1922, when Tom transferred the title back to the King Ranch as full payment for the indebtedness he had undertaken during the ruinous years of failing cattle markets. In the trade, Alice got her husband's ranch back, plus the Sante Fe. She was the only child to leave the King Ranch.

Alice, allegedly the prototype for Edna Ferber's "Luz" in *Giant*, continues running her ranch today. Now in her early nineties, she rode horses well into her eighties. She is much like her grandmother, Henrietta King, who was so disturbed by the ostentatiousness of the diamond earrings that Captain King gave her that she had them enameled black. In spite of her wealth, Alice, with the help of her children, continues to run the ranch with a tightfisted frugality that came from decades of being land-rich and cash-poor.

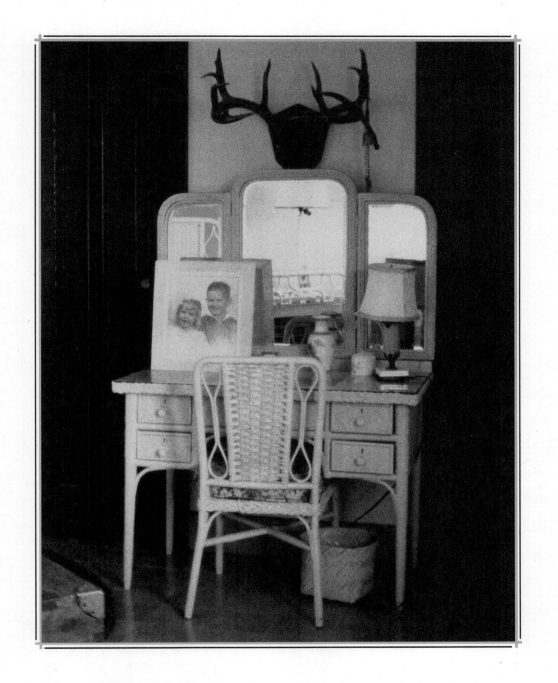

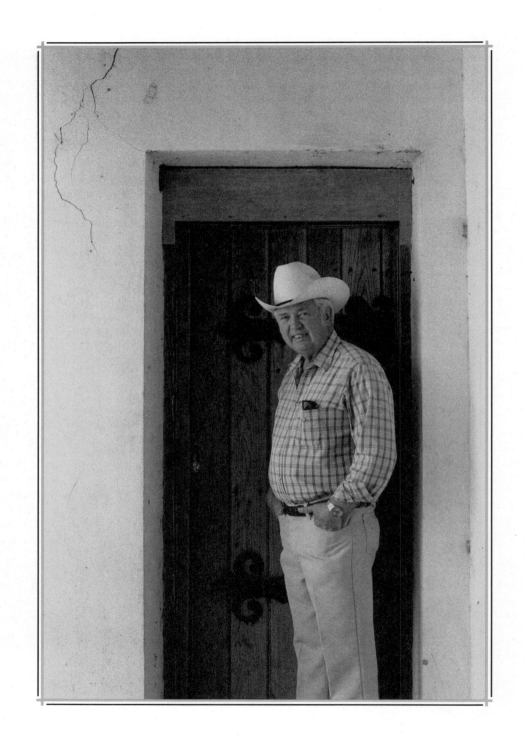

"And the nights—there's something spiritual about them. When you're down here alone, and you listen to the ghost winds howl, the next morning you know who you are. It creates a peace within. You wake up a lot stronger."

Tom Allen
Jesus Maria Ranch
Near Hebbronville

he house rises out of the scrub in an explosion of self-expression. From the distance of Highway 16, this incongruent manor house would seem far more at home on the European countryside than skyrocketing out of the South Texas brush. Rusting letters on the old iron gates spell out JESUS MARIA. A connecting barbed-wire fence, fragile and plagued by age, seems insufficient protection for such middle-of-nowhere affluence. A moat with a drawbridge would seem more appropriate. The former showplace 20 miles south of Hebbronville has been closed for 45 years. Even while it deteriorates under a hot Texas sun, it remains Dom Perignon in a land of Lone Star.

The original ranchhouse at Jesus Maria was built in 1900 by John Henry Allen for his daughter Josephine. In the early '20s Josephine's son, John Houghton Allen, spent time studying in Paris, Mexico, and New York. John returned to his boyhood place and remodeled the ranchhouse after an imposing French Normandy farmhouse with a high-pitched roof so "the snow wouldn't stick." He built fine stables and a polo field. He would invite friends out on occasion, but only rarely. The solitude and barrenness of the

scrub offered up an eagerness in him to put his thoughts on paper.

Not far from the ranch on the desert landscape was a picturesque Mexican hacienda called Randado. Time and the twentieth century had passed by this tiny white-walled village with stone houses and thatched roofs and flowers that bloomed from every window. Its state was perfect and overflowing with the passion of Mexico, and John was captured in its harmonic time warp. He would later write, "A man can never get away from his home country.... It's like running away from God. I've been everywhere, done everything to put Randado out of my mind. You can take me away from Randado, but you can't take Randado from me." He wrote lovingly about the hacienda and frequently mentioned it in his only novel, *Southwest.* John squeezed every drop of life Randado had to offer onto paper, and when the insulated hacienda, wrapped in the tradition of Old Mexico, began to fade, so did John's interest. He packed up, boarded up, locked up, and left the Jesus Maria for good.

Forty-five years later, Tom Allen, John's half brother, took a long step out of his pickup and walked over to unlock the rusting iron gates. The squeal of the opening gate startled a roadrunner into a patch of blooming cactus. Beyond the gates, a seldom-used road wound through froths and shafts of thin-leaved mesquites covered with dust and hibernating silence. When the house came into view, I felt deep inside that I was about to violate an abandoned shrine—one left in quick exodus for serious reasons.

Tom fiddled with a hank of keys. Close to the front entrance a baptismal font gathered rusty beer cans. An unfinished grotto housed dried tumbleweed and splendidly woven cobwebs. Tom reached out as if to keep a child from falling and said, "Duck when I open the door." The old hand-hewn door opened slowly on its iron hinges, whimpering a tired, drifting sound. A full-winged owl flew out into the light, grazing the top of my head and landing on a nearby mesquite. Tom and I, aided by a comforting flashlight, followed its path into overwhelming darkness. Screeching, high-pitched chirping noises came from within the bowels of the old home. The invasion of foreign light had awakened sleeping bats, which, clearly in angst, dove in frenzied dips.

The place smelled of warp and old yellow paper, and the floors dipped and waved from neglect. One watched carefully where one stepped.

A wide hall led to the dining room. Muffled expressions of wind and thin slivers of light seeped in through wooden slats placed over the windows for protection from vandals and weather. The old, elegant rams-head furniture was covered with cobwebs and layers of dust, and the room was the color of concrete, fixed in quiet neglect.

It was here that the dinner party of legend took place. According to South Texas gossip, the tale goes like this: After a day of deer hunting, two *compadres* from Hebbronville stopped in at a

little cantina for a beer before heading home. John Houghton drove up. The men asked him to join them. After several *cervezas* (beers) John invited the men "up to the ranch for dinner." They freshened up the best they could at the cantina—since home was 20 miles away—and headed out for an evening at a place distinctly exclusive and off-limits to just about everyone.

When they arrived, John answered the door wearing a black velvet smoking jacket and a silk ascot tucked in at the neck. John seated his guests in the library and served drinks. An hour later dinner was announced by a servant. The men, who had been in the brush hunting all day, resisted the urge to rush to the table. In the dining room, antique silver and crystal shimmered in the candle-light; so did the oval tins of sardines sitting in the middle of each plate. Three bites and a cup of coffee later, the hunters beat a "hell-on-wheels" retreat back to the cantina for a bowl of chile, hot tortillas, and a six-pack of beer for the trip back to town.

From the dining room, Tom and I walked sideways through a rusted swinging door that refused to swing into the kitchen. Something unquestionable glopped around my boots. Now and then we would shoo away a stray bat or trip over the buckling floors and an occasional rat, but I was not prepared for what was in the kitchen. Vines had grown in a tangled mass through the kitchen window. Swarming bees pulsated in a mass so great the vine moved easily, spilling forth sounds of a quiet disconsolate hum.

Beneath the mass, carved on the kitchen sink were the Gaelic words CEADE MILE FAILTE (one hundred thousand welcomes). Disregarding the swarm of bees, Tom reached down and pried open a trap door that led to the dark and cobweb-filled basement. "Want to see the basement?" Tom asked. "This is where my brother stored his ammunition during the war. He thought if we were ever invaded this would be a good place to hide." Having long ago tossed away my degree in maniacal masochism, I declined the offer.

Instead, we walked down a short flight of stairs into a large, cavernous room with a ceiling that reached 40 feet upward. Tom pointed the flashlight's solitary beam toward a wall lined with bookshelves. Above the bookcases, ancestral portraits flaked like Post Toasties. Below, mice nested in shredded volumes of what was left of a fine collection of books. Personal elaborations suffered in Dickensian gloom. The damage was irreversible.

Tom and I then visited a more recent addition to the house. "John built this for his visiting in-laws," said Tom. The newer part was less formal, lending itself more to the bunkhouse school of architecture. Tom dusted off a couple of chairs before we sat in them.

"My dad was married to Josephine Houghton," said Tom. "Her father was vice president of the American National Bank of Austin. He acquired 30,000 acres down here in the early 1900s for a buck an acre—you want to cry?

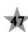

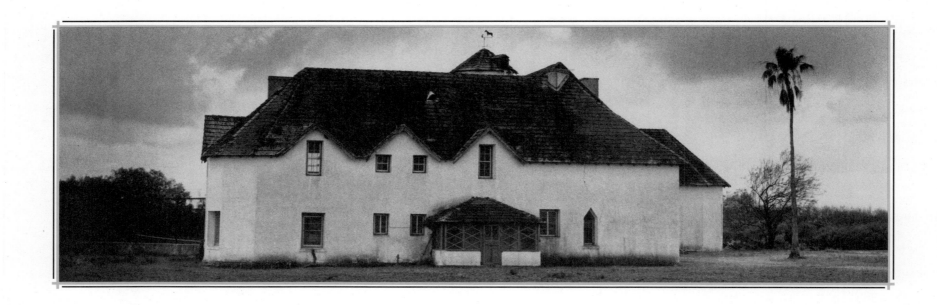

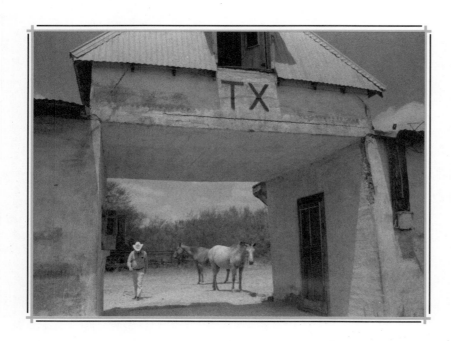

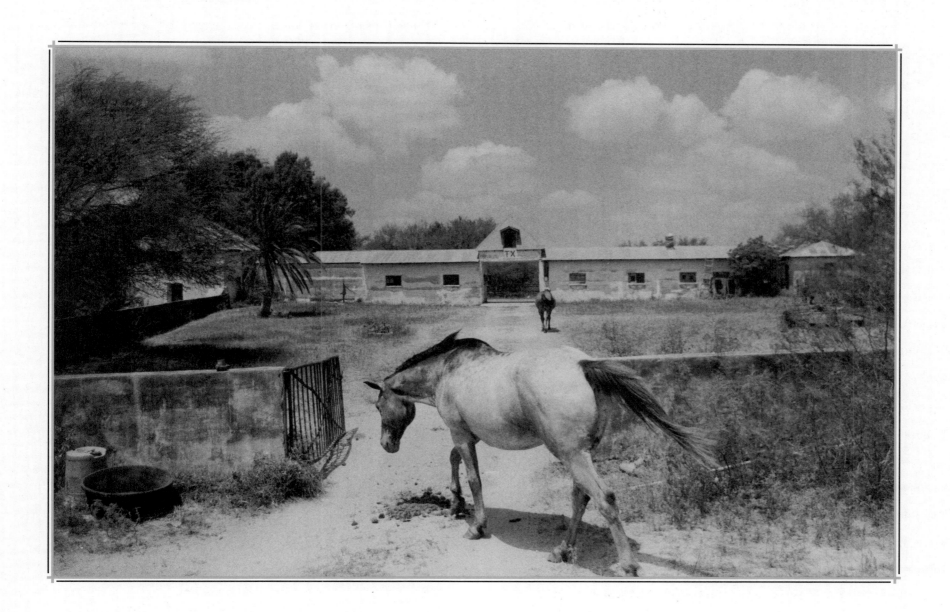

"When we were kids out here we had tutors, and our school was in the old chapel that has long since been torn down," said Tom. "My mother fretted all the time because we'd ride with the cowboys. My dad didn't sleep well, so he'd get up about three or four in the morning and had everyone roping and saddling horses before dawn. It was spooky out there before daylight," Tom said. "We'd go out before sunrise and ride eight or ten miles before we got to the cattle. We'd work cattle all day and wouldn't get home till long after dark."

Tom smiled; his childhood fondness for cowboy life was evident. "When we shipped cattle, we'd dip them for ticks, then drive them down a sandy road toward Hebbronville," he said. "At noon we'd gather around the chuck wagon, eat, take a siesta during the heat of the day, and head toward Hebbronville. It took us all day. At night the guys would stay in town drinking beer and raising hell.

"My brother and I were not allowed to stay for that. Mother made the foreman bring us back to the ranch."

Life at home could sometimes be riskier than life with rowdy cowboys. "One time this nurse we had was scrubbing my brother and I down in this old tub with legs on it," Tom recalled. "While she was scrubbing us, a rattlesnake crawled up between the wall and the tub. The maid panicked and ran out."

Speculation still surrounds John Houghton Allen and his reasons for leaving. Today he and his wife, Ann, live in a little village outside Tucson, Arizona, in a small fading adobe house very much like those that he wrote about in his Brigadoonesque Randado. His family coat of arms is plastered in the adobe; it is labeled simply HOUGHTON. Nearby in crudely painted letters an old sign reads KEEP OUT.

"I could no longer write there," was John's only comment about leaving South Texas. He shared this in a visit kept brief because he was very ill, slightly agitated, and certainly in no mood to be drilled by a total stranger. He suffered greatly from a fall from his horse at one of the few polo games at Jesus Maria. He said he had never been the same since. Through short, fast breaths it was still evident that nothing in his life had ever replaced his walled Brigadoon. He had published nothing since he left his florid palace on the prairie, a place that shared the glories of Mexico on the new frontier of Texas.

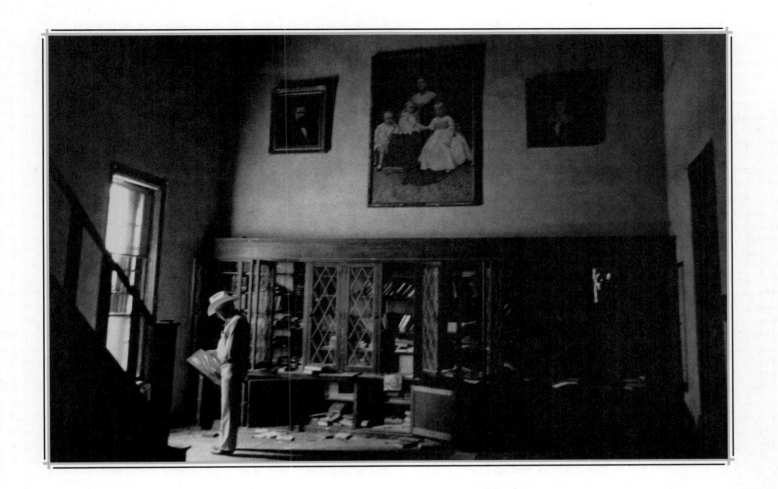

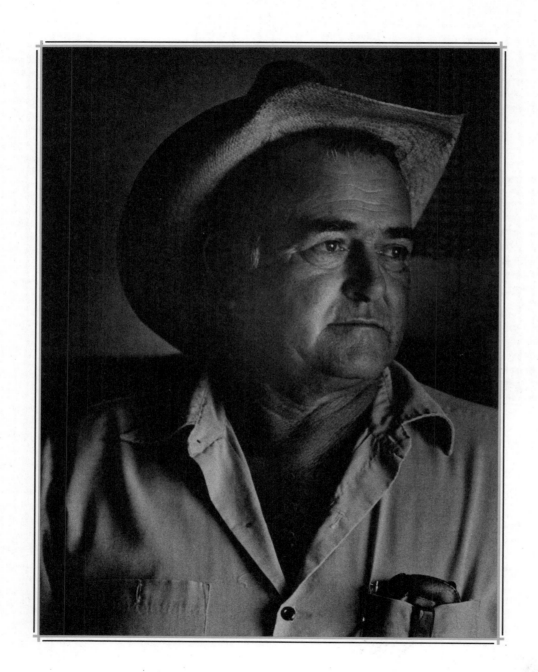

"When it comes time to decide which child gets which piece of land, I'll do what my Daddy did: draw them out of my hat."

Assencion "Chon" Martinez
The Brazil Ranch
Near Hebbronville

The drought is into its seventh month.

It's early summer, 112 degrees in the mottled shade of the spindly leafed mesquite trees. "Chon" Martinez's un-air-conditioned truck bounces and squeaks through the grassless, scrubby range of Brazil Ranch, its radio squawking the now-monotonous report, "No relief in sight coming from the Valley as far as the weather is concerned."

The cattle will soon rush the truck when they spot it, its bed hauling cottonseed cake, their only salvation from starvation. "Chon" will wade through their bawling, thinning bodies untrampled in spite of their impatience, and fill a trough so old it looks like an ancient dugout canoe. Cactus grows through its cracks from the inside out. He talks while he drives, his Mexican accent deep and rich with a mañana patience, and warm—like coffee at dawn. His house was built by his grandfather 70 years ago, he says. As for himself, he was 20 days old when he came here. Now he's 57, and he's been away only three years and 13 days, when he was in the service.

Oh, there have been changes. Lots of them. Changes in the

breeds of cattle, the prices of cattle, the way they are worked. He uses a pickup now instead of a horse.

The cows follow the pickup to the pen, and he closes the gate on them, especially in this kind of weather, because there is no grass. He used to sell cattle only in the summertime, but now he sells them all year, taking them to Hebbronville to auction. From there they go to a slaughterhouse or to a feedlot or back to another ranch. When he was a boy, there was a lot of help with the work. People had to work. Now they don't have to work, he says, everything is given to them. And there are very few old ranchhands left. They have all moved to town.

When there is no rain, then it comes out of the pocket, he says. If it does rain, you still have to take care of the cattle, see that they are all right, feed them some minerals once in a while, doctor them, but it does not require as much as when it's dry. When he was a boy, it was a much bigger place, and he even got lost on it once. Altogether there must have been 25,000 acres.

All of that has been cut up now. Every generation it gets smaller and smaller. From his grandfather it changed hands to two boys and a girl. His daddy had two children, his aunt had four, his uncle had six. And now he's going to divide the piece he inherited, The Brazil, into four different pieces.

From one fence there is going to be one piece, over there is going to be another, and then two more, just as his father had told

him when he split it. This, The Brazil, would be his, the other would be his sister's. Nevertheless, his granddaddy had ranched this place, his daddy had ranched it, and now he, Assencion "Chon" Martinez, ranched The Brazil. And what does "Chon" think of when rain finally comes to break the drought? "Las Vegas," he replied.

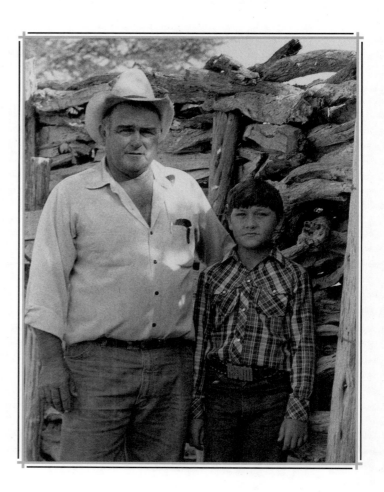

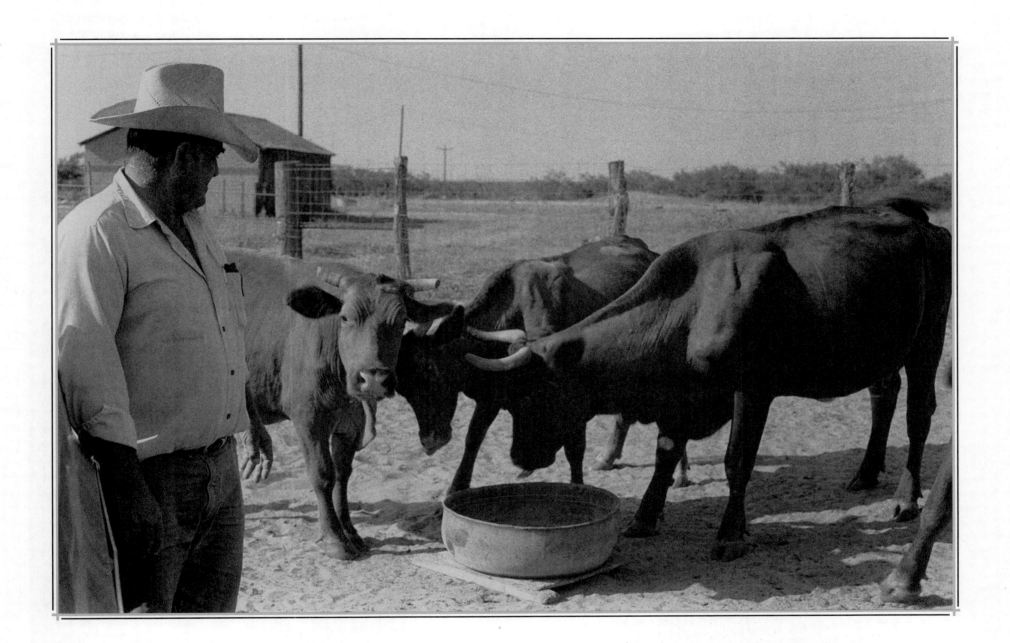

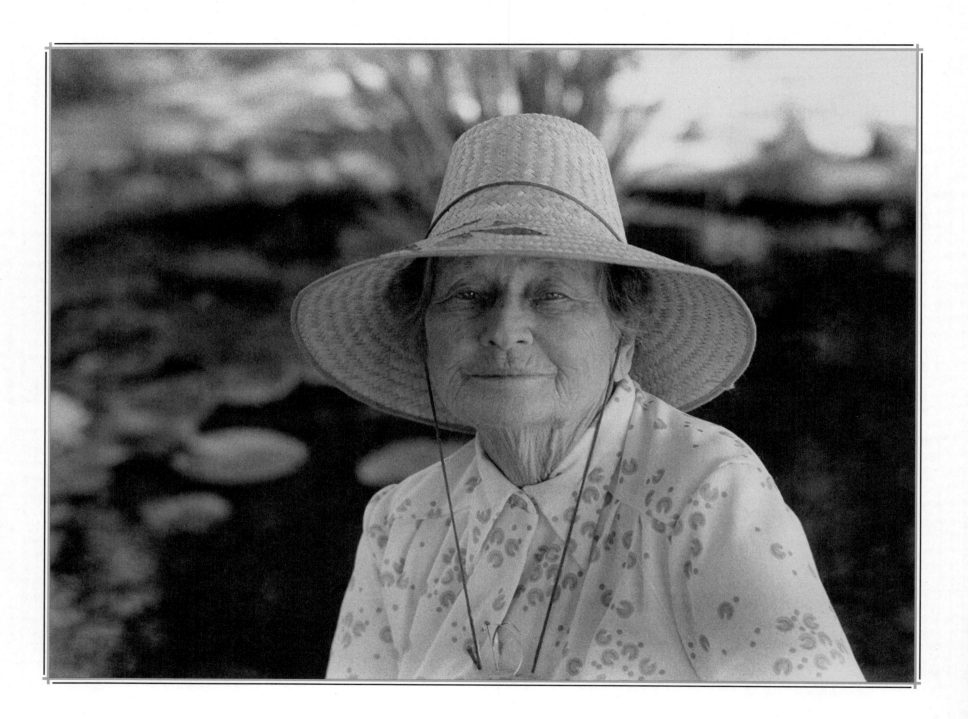

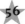

★ HELEN HARBISON ★

"It's hard to recall the worst drought. The last drought always seems like the worst one. But there was one drought that left the prairie clean as the kitchen floor. There was simply nothing there."

Helen Harbison
(1896-1985)
Harbison Ranch
Near Hebbronville

She arrived as a small child with her family by train from Kansas on February 16, 1907, and was greeted by her father, a buckboard, two mules, and a sunlit prairie riotous with wildflowers, which she picked in celebration. Before nightfall, they were struck by a sudden blizzard that drove them to the Sponsler's ranch for shelter. That first bitter winter they moved in with the Danhausers, miles from their unfinished house, and thus began their lives as South Texas settlers.

Back in Kansas, little Helen had been told of bountiful South Texas fruit trees, just waiting for her to pick from on her walk to school each day. Instead, there were only cactus apples, a tree-less plain, and no school within walking distance. This was a land of longhorns, coyotes, droughts, high winds, and freezes that by 1908 had sent most northern immigrants packing. Her father would have gone too, but her mother said no, never again. They stayed.

In 1921, Helen married Pel Harbison, a Texas Ranger. He moved her from Hebbronville to a nice spread with a dairy farm. Eight years and six children later, the ranger's wife had made a home of the concrete, tornado-proof fortress of a house he had built for

her. There should have been a seventh child in the winter of 1929. But on the night Helen went into premature labor, Charlie Roddie had come over to work on the 32-volt farm plant—the only electricity they had for running the dairy equipment. She hated to interrupt their business; it seemed important, and she could wait. But she waited too late to get into town, so the baby was born in a chilly concrete house warmed only by a fireplace. If the men had finished a little earlier, or if the doctor had not been in Falfurrias that night, or even if the month had been May instead of December, the baby might have lived.

Pel Harbison died in 1956, and Helen continued to run the dairy farm until 1965. All the labor moved to town or went on welfare, so she sold the dairy cattle and took up ranching. She was just 65 then. Now at 80, she has seen the land worked by a span of mules (better than a tractor and cheaper to keep), has watched the coyote-carried mesquite seeds take root and banish the prairie grass to mere memory, and has weathered the drought of 1980. With her closest neighbor three miles away, she stays here in this trying place. There is freedom here, and the people are friendly. When the children ask her what to do with the land after she is gone, she crackles a wise laugh and answers that she won't have to worry about that. That will be their problem.

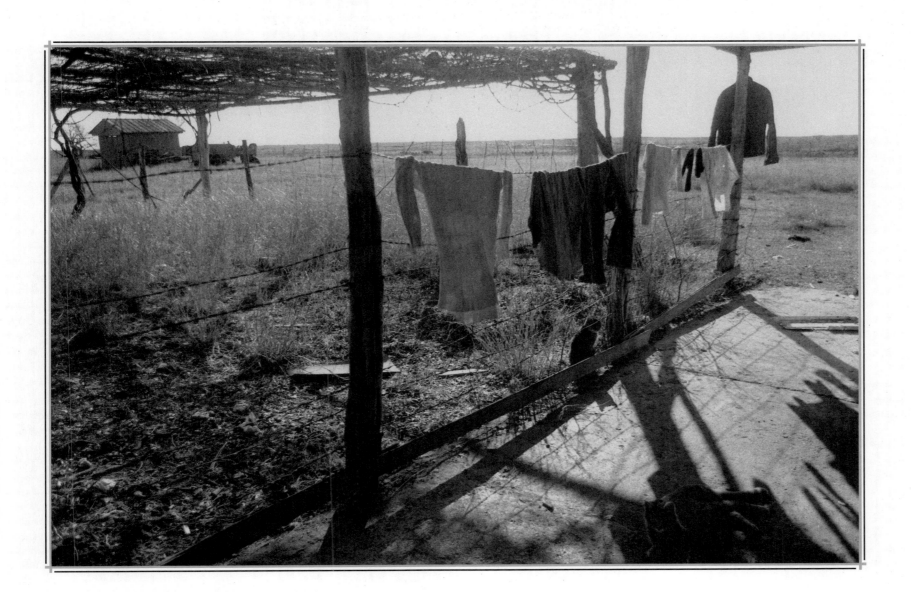

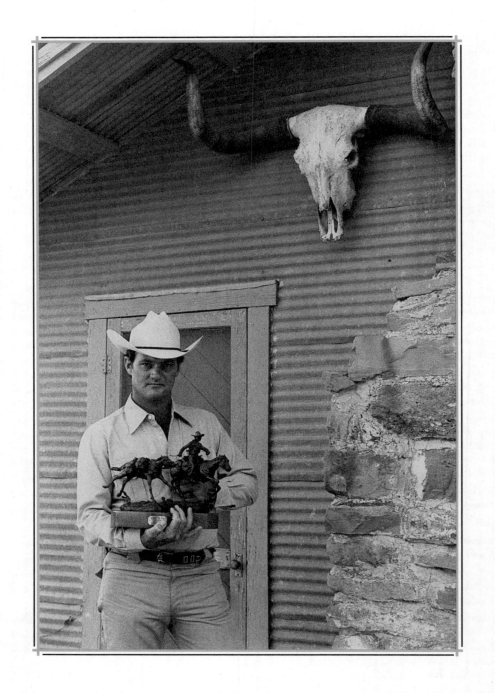

"Chris, if you get anywhere in the art world, this bronze is the one that's going to help get you there."

Amon Carter, Jr.

James "Chris" Hellen
La Ebonita Ranch
Near Hebbronville

Down the caliche road, the ranchhouse appeared in a patch of green, water-fed grass. Near the road, longhorns the color of parchment and old rust squeezed under the shade of summer mesquites. Brush and landscape were idle under an immodest sun. The stamp of drought triumphs, at least for today.

When I pulled up to the frame ranchhouse, a tall, lean, boyish-faced Chris Hellen ambled out to greet me. I had been in and out of Hebbronville for the last 20 years and had known Chris all my life. He approached cautiously, like a man dipping a big toe into the water before jumping in. His misanthropic look probed for the phony. It was a South Texas ritual to which I was now accustomed.

I followed Chris through a crushed path of grass that led to the back screen porch. Inside, the house was 34 degrees cooler. "This is the first time I've turned on the air conditioner this summer," said Chris. "I did it because you were coming. Normally, we don't use it."

Chris's attitude toward air-conditioning is typical. Those brought up in the Brush Country, ingrained in ranching values, thwart modern conveniences. After the wheel, the saddle, and the

pickup, who needs a contraption that refrigerates 110-degree air, making it a livable 75 degrees?

"We also don't own a TV," Chris volunteered. "Too many people are chained to them." Nearby, Chris's children sat on the sofa, both reading books.

The third-generation rancher, whose great-great-uncle was one of the first Anglos to homestead the Texas-Mexico frontier, was crossing the t's and dotting the i's in the unwritten laws of old-school tradition. Chris offered me a glass of iced tea. The room was now beginning to fill with deliciously cool air. Chris said, "After my great-great-uncle, W. A. 'Bill' Waugh, left Ohio and struck it rich in the California gold fields, he moved to Brownsville. After a stint with the Texas Rangers during the Cortina War, Waugh returned to La Salle County, where he ran a small cattle, horse, and mule operation. La Salle County was still open range, desolate and lonely country. Uncle Bill changed all that when he turned the ranch's headquarters into the area's first post office."

When the railroad needed a new depot, Waugh cut a 200-mile wagon road through the brush and sold the I&GN Railroad the lumber for the new depot. In 1883, Waugh bought El Sordo Ranch. It was one of the first American-owned ranches in Texas.

Chris took a long drink of tea and continued. "My grandfather, C. W. Hellen, came here when he was sixteen, seeking a cure in the dry climate for his tuberculosis. One of his first jobs was operating a hand-dug well on his uncle Bill's El Sordo Ranch. He had a contraption that he hooked up to the well. A mule walked around in a circle and brought the water up to the surface, and from there it dumped into a trough. The ranch was located on the Camino Real, then a hot and dusty road that ran from Zapata to San Antonio. There was stage traffic then, so my grandfather sold water to the passengers and allowed the horses that pulled the stagecoach to water up for a small charge."

Chris's grandfather Hellen later homesteaded his own land, which meant that he had to live on it for six years before he was entitled to buy it from the government at a good price. The place was 18 miles southwest of Hebbronville, in the middle of "no man's land." Hellen was over 30 before he returned to Washington, D.C., to marry his girlfriend, with whom he had corresponded over the years.

"He ended up marrying her sister, Alice Finkley," Chris said, "and they built and lived in a house right over there where my parents live today, about a mile from here."

The Washington lady never cared much for South Texas. Her life in Washington had been on the upper end of the social scale. "The dust and the dirt and the way cowboys acted were more than she was able to grasp," Chris said, "and the food—she never liked beans, camp bread, rice, and stuff like that. She liked fancy food."

Several years ago, Chris was diagnosed with an untimely illness. While Chris was undergoing tests, Dr. Bowman, a surgeon, dropped by his room and noticed his sketches of cowboys and cattle. Bowman asked Chris if he'd like to sculpt.

"At the time, the subject was foreign to me," said Chris. "When I left the hospital, he invited me to his house and ran me through the basics. He gave me a ten-pound slab of wax and said, 'Go home and try your hand at it.'

"When I returned my first piece, a Texas longhorn in wax form, Dr. Bowman liked it. He suggested that I cast it in bronze. In a matter of weeks I had sold out of my first limited edition."

Chris got the idea for his second piece while hearing three old-timers around the ranch discuss the *tequileros* who ran rum during Prohibition. The old men's tales had been so vivid that he began to see things through their eyes. "I named my second bronze 'Border Bootleggers' to commemorate their stories," Chris said. "When I finished the piece, I took it to Fort Worth. There, Amon Carter, Jr. saw it and said, 'This is the finest subject I've seen in Western art in a long time.'"

The demand for Chris's work became so intense that one man flew to Hebbronville for a private art show.

"I got a call from a man in Houston," Chris said. "He said he'd be here in one hour. In exactly one hour, his pilot taxied up in one of those fancy Queen Air deals, landing right here in Hebbronville, out on the Freer Road. I had my bronzes all over the hood of my car. He asked, 'How much is that one?' I said, '$3,200.' He wrote a check, stuck the piece of sculpture in his plane, and was out of sight in ten minutes."

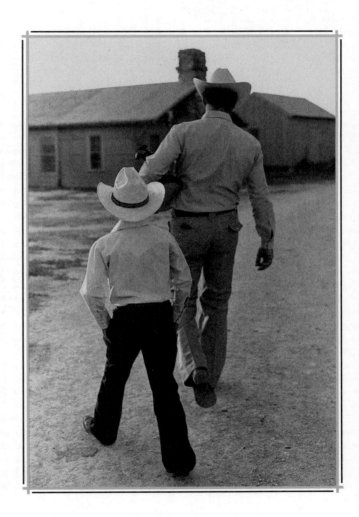

63

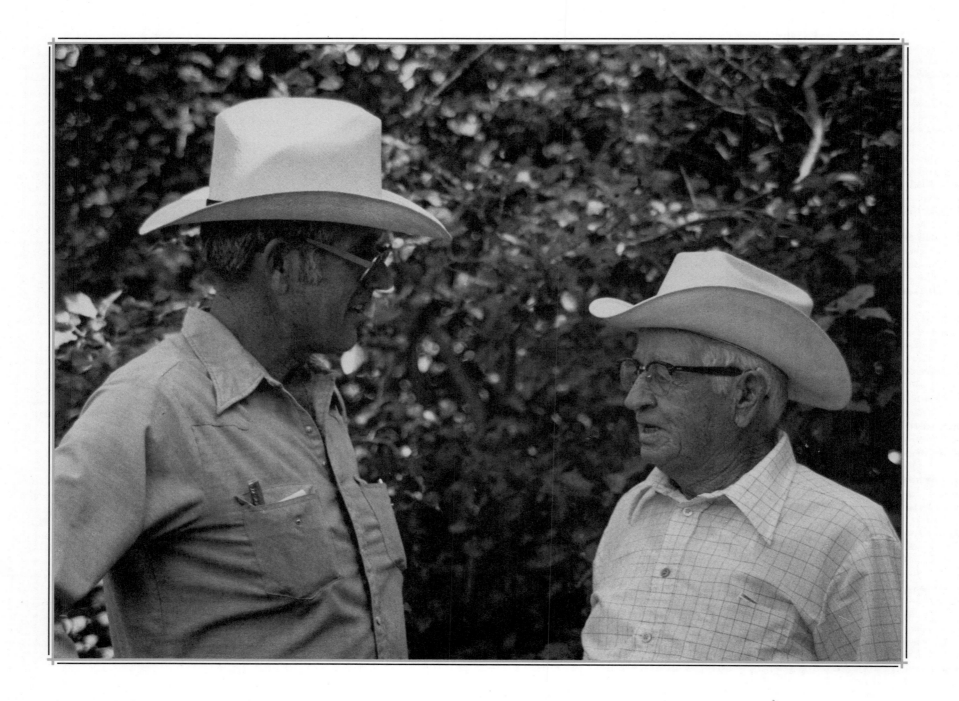

"My grandfather was Captain King's bookkeeper. When he'd go out to pay the help, he would hide the money in a secret box under the buckboard."

Robert Holbein
(1903-1987)
El Repose Ranch
Near Hebbronville

They were the vanguards of the early raw cowboy country, primary settlers who made it on their own without stealing land or cattle from Mexican families whose land had been granted to them by the King of Spain.

Amply supplied with staying power and wielding Teutonic grit, Ruben Holbein, a descendant of artist Hans Holbein, came to Texas from England. His sponsor was Henry Lawrence Kinney, the man responsible for colonizing Corpus Christi.

Ruben Holbein helped colonists find and settle land on the Texas frontier. Later he met Captain Richard King, who was in need of an experienced man to help him with his unpopulated and unmanned empire, the King Ranch.

Captain King trusted Ruben Holbein. Serving as King's bookkeeper, Holbein went up the Chisholm Trail, delivered a herd, and returned the money safely to King, hiding it in a box attached to the underside of his buggy. Back on the King Ranch in Texas, he kept books on all cattle bought and sold on the ranch and kept close track of expenses. Once a month he took a buggy into Corpus Christi to buy groceries and supplies for the ranch.

Captain King showed his gratitude to Holbein by leaving him 2,000 acres of King Ranch land in his will. At Holbein's death his widow, Sarah, sold 1,995 acres back to the King Ranch. A faulty survey withheld five acres, the possession of which remains in the Holbein family today. There are no roads leading to the land; it is accessible only by helicopter.

Robert Holbein, Ruben's grandson, sat in the coolness of his living room in Hebbronville, undisturbed by the resigned, melancholy noise of locusts in angst. His eyes were vibrant blue against a tanned face lined at the corners like a dried creek bed. Behind them lay a matching wit.

Robert swept back his gray hair with a brown hand and said, "The name of our ranch in English means *repose*. It pays to repose." His eyes turned up at the corners when he finished the sentence. He spoke with a clipped, slightly English accent that has been associated with Holbein men for three generations.

"When my grandfather died, my grandmother, Sarah, took my father back to Corpus. She did what widows with a little money did in those days: she invested in land down in this part of the country. She purchased several ranches from families landed by the King of Spain.

"One was called Las Cuartas and the other was called Las Animas. Both are in Jim Hogg County. We've had this land in our family since the 1900s. No one ever wants to give up what belongs to the family. That's why there's never anything for sale around here," Robert explained. Families dating back to the 1900s and earlier are not uncommon around Hebbronville. Many were there before the railroad came in 1881. Upon completion of the railroad, Hebbronville was founded. The town was originally called Peña Station. Francisco Peña refused to sell his land for a townsite for the Tex-Mex, so the railroad made a deal with James Hebbron to put the townsite on his property. The old train station was loaded up on a flatcar and moved one-and-a-half miles west. The people and the businesses moved with the depot. At one time Hebbronville shipped more cattle annually than any other place in the United States.

"It wasn't Dodge City or anything like that," Robert said. "We had law and order then—more then than we have now. People respected the sheriff."

There was a pause in the conversation while Robert answered the door. Bill, his six-foot-five-inch son, had come over to tell his mother good-bye. She was leaving for London the following morning. Bill volunteered a story he remembered from his childhood.

"Back in the days of Prohibition, my dad and his twin brother Ruben, Sheriff Alonzo Taylor, and Charlie Hay went out to my grandpa's ranch and ran across a bunch of bootleggers camping out under some mesquites. Their pack train of mules was loaded with booze. The men went charging into camp. Taylor led the raid.

Later he and Captain Bill McMurray took the captives to town, leaving Charlie Hay and my Uncle Ruben to bring back the liquor-laden pack train. Well, both Charlie and my uncle were somewhat fond of the contents of the pack train. They began sampling a few bottles. Some time later—much later—they arrived bottleless in Hebbronville. Both men claimed the bottles fell off and broke on the spot. After that, there were a lot of people seen headed out to my grandpa's ranch at the strangest times of day for a long time to come."

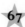

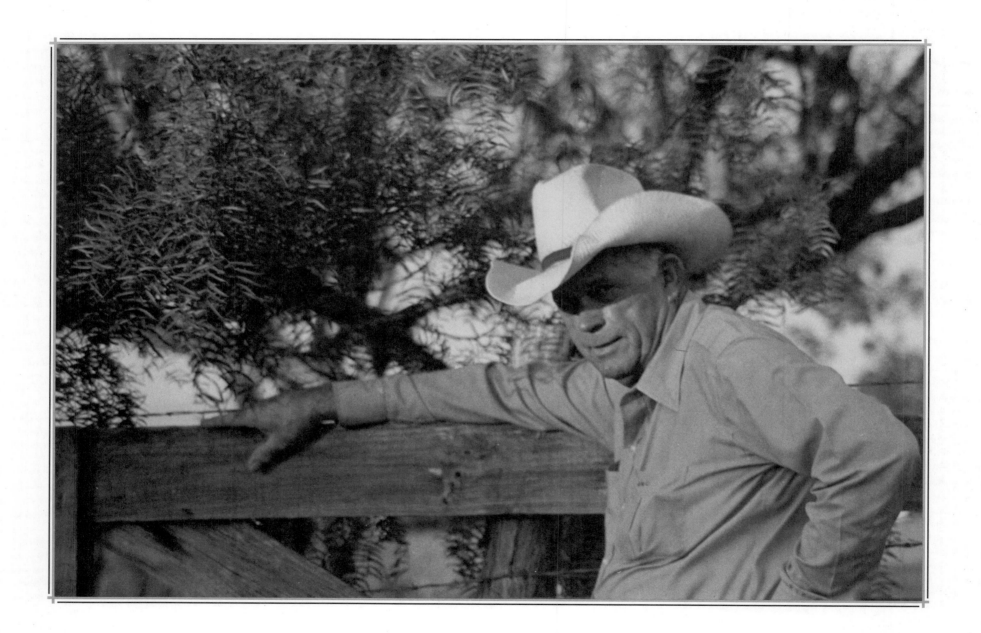

"It's wonderful to see you, honey."

Holmes Dinn
Dinn Ranch
Near Bruni

ithout warning, the black asphalt road out of Hebbronville merged into rough washboard caliche. The road followed a wave of small, rocky hills, leaving behind flat and fallow land. Ahead, one hill rose steeply. When I reached its top, I stopped the car.

My view was South Texas at its best. A recent shower had greened up tides of rolling brush. Cactus bloomed in clumps of pink. The rigors of drought were gone, at least for today.

The rugged country that surrounds the Dinn Ranch was familiar. I spent time as a child exploring there. Its sameness, 40 years later, brought on a rising contentment that released a mute spirituality. Nothing had changed. The only concession to this century was a smattering of asphalt and telephone poles that leaned.

In retrospect, adult life on the Dinn Ranch during the '40s had to be harder than it appeared—milking cows, churning butter (children took turns, but adults always finished the chore), and baking bread. The men left before dawn and returned at dusk smelling like sweaty horses and old tanned leather.

For children there was fun from morning to night, such as wading in shallow tanks on squishy green moss that oozed between

your toes. There were barbecues, windmills that clanked when the wind blew, fishing in muddy tanks, and horseback riding on a black horse that threw me—my first and last ride on a black horse.

Winter nights came early and were long-lasting. There was no electricity. At dusk, kerosene lanterns cast a scrimmed golden light. Near the fuel's end, the wick brightened and popped tiny sparks before dying. In the dark, the forceful winds of a fresh norther would beat canvas tarps against the sleeping porch in an arranged clarity of beats. Sleep came in different tunes.

In the morning, smells from a mesquite fire drifted onto the porch through rusty wire screens. In the kitchen one of the ranch hands brought in a hot Dutch oven filled with *panoche* (camp bread) cooked on the open fire. The puffy bread was scorched black on the bottom and had a moist, white middle. Coffee simmered on a wood stove—morning, noon, and night.

The Dinn Ranch was the perfect place for a child with an active fantasy life. Scratchy, crawling noises came from an unused fireplace. I was convinced that black and hairy "somethings" lived there. "Just your imagination," grown-ups would say. One day one of the "black hairys" wandered out. It was a long, mean, multi-legged bug called a vinegarroon. It was, in an instant, a puddle of lime-green death, brought on forcibly by the heel of an adult boot.

As I drove down the hill toward the ranch I passed two Brahma bulls in a nearby pasture. A configuration of sky set them center-front in a stage of brush. A few minutes later, I drove up to the ranch house. Holmes Dinn, tanned to the hat line, was sitting on the front porch. Time had not dimmed his Christmas-tree smile. At 68, he was as handsome as ever. We visited, discussing old times and the usual topics: friends, family, children's occupations, and children's children. As we reminisced, Holmes told of his grandfather, James L. Dinn, who came to this country from Ireland as a stowaway on a boat.

Holmes's aunt, Mary Dinn Reynolds, was the first Anglo woman born on Padre Island, at that time a long, desolate, uninhabited strip of sand. Mary Dinn Reynolds, born on December 10, 1874, described her life on the island in a newspaper interview in 1950, when she purchased the first car sticker sold to visitors at the opening of the causeway connecting Padre Island to the mainland. "About a dozen families lived on the northern tip of Padre. The little community was called Head of the Island. I remember being told that after the Indianola flood they picked up barrels of salt pork, bolts of dress goods, kegs of molasses, and all sorts of staples on the beach."

The Dinn family moved from Padre Island in 1876, settled in Live Oak County, and continued ranching in Duval County.

Stories of the past ended with the sun's departure. Distant sounds of children came from the ranch foreman's house.

Holmes and I had a glass of wine on the front porch and toasted the rewards of rediscovered friendship. Do we ever outgrow the nurturing of old friends?

 It was good to be home.

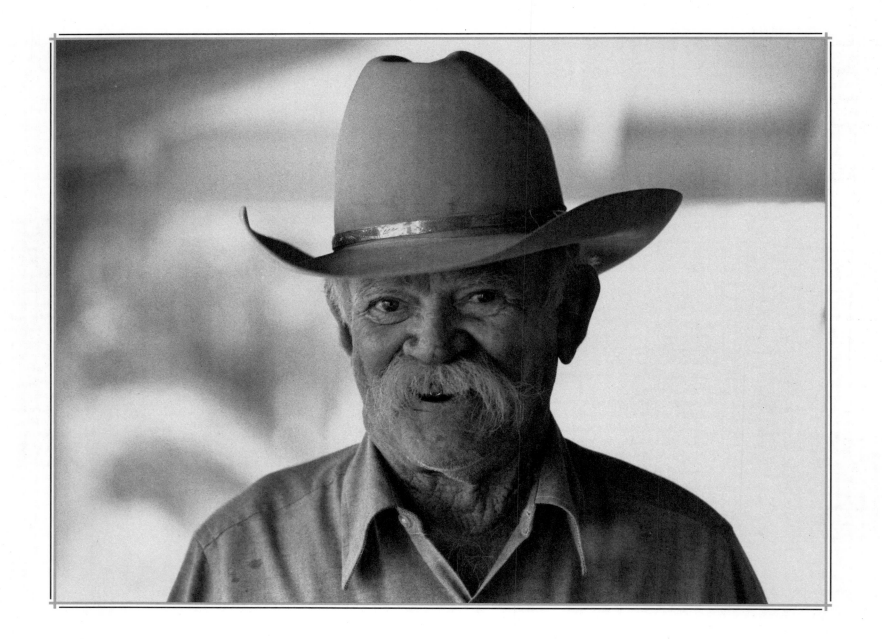

"Damn, I envied her. She could run and jump in the back end of a pickup, then jump off and run play with her bird dogs. When you're laid up, you realize what privileges you had that you don't have anymore. It all goes with wanting to live to be old. You're gonna have to pay for it one way or another."

"Tio" Dennis McBride
La Estrella Ranch
In Realitos

In the back yard of Dennis McBride's home in Realitos, two worn-out wagons rest in advancing brush. Both have been there for 76 years. Dennis came to Realitos in one of them when he was a child.

The bowlegged and spunky-eyed Dennis sat in the living room of his rambling Victorian house, nursing a leg—in a cast from recent surgery—and a bourbon. A falling sun dappled the carpet inside the living room with tattered patterns of light.

Skulls, hides, horns, and skins decorated walls, floor, and ceiling. Two worn and mysterious airline seats served as a "sofa," and in the middle of the room an upright vacuum cleaner wore Dennis's Stetson on its handle. ("Well, hell, it was handy," said Dennis.)

Dennis pointed to a curling sepia photograph over the fireplace and said, "That's old Grandpa. He came over from Ireland as a sailor on a sailboat—*not a steamboat, but a sailboat*. He made several trips, bringing families over to Corpus for colonizer Henry Lawrence Kinney, the man who settled Corpus Christi. Grandpa's name was James McBride."

James decided to stay on land for a while, so he went into

the freighting business. He hauled cotton in *carretas*—those old wooden carts pulled by oxen teams—down to Brownsville. Because of the Civil War all the Confederate ports were blockaded by the Yankees. There was a little seaport town in Mexico called Bagdad across the Rio Grande from Brownsville. Steamboats would transport cotton to Bagdad and sell it. From there, the cotton was shipped to Europe.

"Before each trip," Dennis said, "my grandfather would hitch this old bell mare to one of the wagons. After he got paid for the delivery, he would wait until midnight, slip out and remove the bell from the mare, and saddle her. Then he slipped off into the night, avoiding the possibility of bandits robbing the carts returning to Corpus."

Dennis's father, Peter McBride, was in the dairy business. Every morning, after the cows were milked, he would take off in a buggy with a big old milk can in the back and deliver the milk. Everyone in Corpus brought their little containers out to the buggy when he arrived for him to fill them up. Peter McBride accumulated a little land here and there—about 2,000 acres.

"He went the steer way till he got badly bent in the Depression," Dennis said. "Took him a long time to recover. You can keep an old cow and she'll keep having calves, but steers—you buy steers and they just go to feed lots. It was risky business, but it's what Papa liked."

In 1952, Dennis took an adventurous trip to Cuba. "I called old Dr. Northway, the head vet at the King Ranch," he said. "They were shipping a bunch of cattle to Cuba, and I wanted to go. Old Doc said, 'Dennis, I'd be mighty glad if you'd help get these cattle to Cuba.' A few days later we sailed out of Galveston Bay. The trip took three days. We hardly sat down the entire trip. There were 450 heifers and about 50 to 60 bulls. We had to water them in buckets that we carried to them. The cattle weren't used to people getting close to them. They were range cattle. We had to pamper them at a distance.

"When we got to Cuba, there was hell to pay. Their railroad cars were top-loaders, not like the side-loaders we have over here," said Dennis. "We built a ramp with an easy chute down into the car, but the Cuban longshoremen decided that any construction would have to be done by them, so they tore it out and rebuilt their own. God, it was murder. The poor old cows would get at the top of the boat and start down, and you know, it gets all wet and messy, so most of them started sliding and slid all the way, crashing into the railroad car. God almighty, it was terrible.

"After we got them loaded, I flew back to Texas. Ten years later, Castro confiscated the entire King Ranch operation in Cuba."

Dennis leaned over and rubbed his leg and said, "You know, nearly everything in this part of the country used to be a two- or three-day ride away by horseback. You always stopped to see

friends and to rest up and water the horses. People visited more then than they do now. With all this modern transportation, we wind up with no time. It shouldn't be that way. It should be like it used to be. We used to travel by horseback, and the first little ranchito you came to, you stopped, and they gave you a cup of coffee and tortillas. It was a real fancy time, I'll tell you."

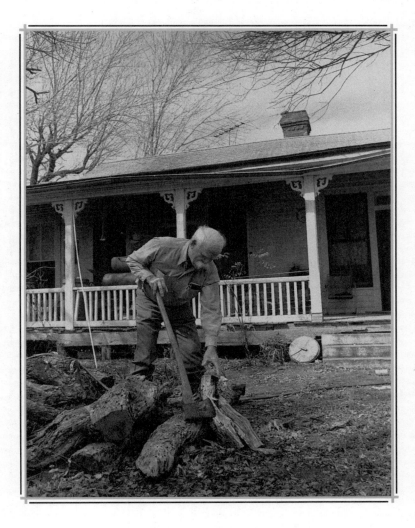

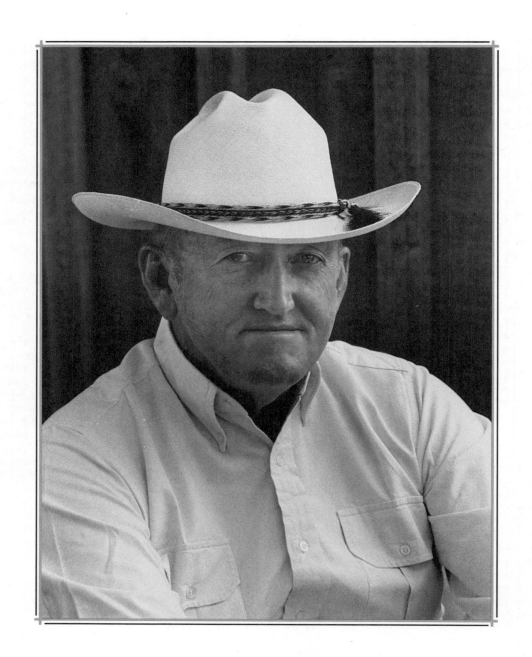

W

"At the Cadillac Bar in Nuevo Laredo, Porter Garner and I used to stand at the bar and shoot rats with our six-shooters when they crawled in under the swinging doors."

Joe Finley, Jr.
Callahan Ranch
Near Encinal

hen I arrived at Joe Finley's cattle ranch, located on the highway between San Antonio and Laredo, I caught a glimpse of a rancher's life to which few are privy. Joe was all the things a rancher should be: towering, with a firm handshake, a personality gaited in Texas Ranger authority, and a jackpot of "Yes, ma'ams." In spite of this myth-mirroring image, Joe Finley was a family man, and all of his six women were "readying up" for a trip to Laredo. The activity level surpassed the picnic at Tara.

Hair dryers coexisted in offbeat harmony. Joe tried to relax in the melee. He had been ready for 30 minutes; his boots smelled of fresh polish and his starched shirt was so crisp that he had difficulty bending his arms.

He leaned back in his leather chair in the den, throwing a frustrated look in the direction of the hair dryers. The room housed a variety of masculine ventures: mounted pheasant, Western bronzes, Indian rugs, a chair made of cow horns, and a rock collection that contained pyrite-filled sand dollars that he'd found at the bottom of a mine shaft in Mexico. At the end of the room, a glass cabinet housed a collection of dolls that belonged to his wife, Mary.

Joe Finley, Jr. was born and raised on the Callahan Ranch, the southern tip of which borders El Camino Real (The king's highway), the road used by the Spaniards since the mid-1600s. The ranch was established by Captain Charles Callahan, a seafaring man who became a blockade runner during the Civil War. Because he was an Irish citizen and flew the British flag on his ship, the Yankees left him alone. He hauled Confederate cotton out of Mexico's port of Bagdad to the Bahamas, picked up trade goods, and returned to Texas. At El Sal del Rey, near Edinburg, he added oxcarts of salt to his wagon train and started the long haul to the point where the struggling Confederacy purchased it for munitions.

The arrival of returning oxcarts sometimes set off riots by housewives clamoring for desperately needed goods that were not to be had anywhere in Texas at the time: sugar, coffee, nails, medicine, muskets, and a few French gowns. Pioneer woman Mary Mavrick of San Antonio remembers in her journal, "After a battle of being wedged up for hours, I finally fought my way up to the counter and purchased a bolt of cloth, one pair of shoes, and one dozen candles. The price was $180. The year was 1861."

At the end of the Civil War, Captain Callahan proved up an 80-acre homestead of brushy prairie land located between San Antonio and Laredo. In spite of opposition from cattlemen, Callahan started a sheep ranch, hiring the best Mexican sheep raiser he could find. After enlarging his holdings and increasing his flocks respectably, he hired as manager his old friend, Colonel William Jones, an exiled Virginian.

On December 20, 1874, Captain Callahan was coming up from Monterrey to San Antonio. He changed horses in Laredo for the last leg of the journey, and a vicious norther caught him on the trail. Captain Callahan, only 38 years old, caught pneumonia and died. By that time the ranch had grown to 70,000 acres.

Colonel Jones, who had taken care of the ranch for Callahan, stayed on and managed the ranch for Callahan's heirs, one of whom was Albert Urbahn, who built several of Laredo's Catholic churches.

Fourteen years after the death of Jones, the ranch was sold to David Beals, George Ford, and Thomas A. Colman. It was converted to a cattle ranch and by 1946 had grown to 200,000 acres. Because of rapid expansion, the ranch was in heavy debt. After Ford and Beals died (within two years of each other), Colman retired as manager. Joe B. Finley, Sr. took his place, and eventually he and Joe, Jr. bought the Callahan.

Joe moved uncomfortably back in his easy chair, his starched shirt wrinkleless, and discussed ranch life on the Callahan. He talked about growing up there. "The average rancher lives broke and dies rich. Broke in his lifetime, and when they go to settle his estate, why, he's rich. Why, we bought for $3. Now it's worth around $500 an acre, but nobody sells.

"We had about 5,000 sheep when I was born. We got rid of them in 1943. The coyotes were too thick and began killing them." The weathered and falling sheep-shearing buildings, where itinerant shearers once sheared bleating sheep, still remain.

Joe looked at his watch. They were due at Goldings, a restaurant in Laredo, at seven o'clock, and it would take 25 minutes to get there. He sighed and pleaded with his ladies to hurry up.

"As a kid I remember finding bones bleached white lying out there in the brush—skulls of humans, probably trying to smuggle tequila out of Mexico and ending up dying in a shoot-out. One time I went into Laredo. Up comes this old Model-T Ford pickup. There were 14 dead rumrunners tied on the pickup and one live one tied in the front seat. They hauled him in and put him in the barber's chair in the sheriff's office. They whipped out a razor and dug all the bullets out of him before they put him in jail. That's when the Texas Rangers had authority."

Joe remembered his father giving him sage advice about life: "Work hard, and if you think you're working hard enough, work harder."

I asked if he would pass that on to his girls.

He answered, "Na-a-a-w. They wouldn't pay any attention to me."

At that point the girls and Mary appeared, ready to go. After good-byes, the family hopped in their Mercedes station wagon and headed for dinner in Laredo. Joe straightened his summer Stetson, turned the key starting the car, and powered the yellow wagon toward the evening sunset.

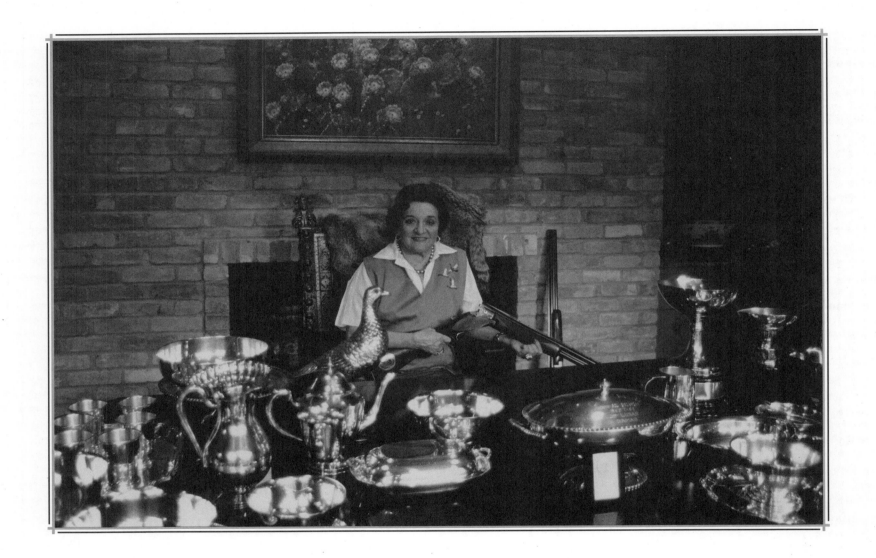

"Honey, when I go down, it won't be on lemonade."

Helen Storey
Luna Media Ranch
Near Cotulla

adre de Dios, it was hot. Dust devils chased me up the river road from Roma, through Laredo, and into Cotulla. There, I was to meet one of South Texas's better-known lady ranchers, one whose character combined the talents of Annie Oakley and Auntie Mame.

I had just set foot in the cool, tiled foyer of her home in Cotulla when Helen Storey said, "Come on, we're going to the ranch."

A man from Houston was flying over from Pearsall in his helicopter to look at 3,200 acres that Storey was selling. By the time she got to the word "selling," we were flying out of the driveway in her car on our way to the ranch. A half-hour later, after a run-through of her attractive ranchhouse, we began to watch the hot sky for a glimpse of a helicopter. Within minutes the only thing that had stirred the air in weeks landed in the middle of a droughty pasture.

A Robert Redford look-alike got out of the helicopter and walked over to meet us. He was square-jawed, handsome, and monogrammed from head to foot. The energetic tycoon was rich in real estate and eager to invest in ranchland. When we boarded, he poured icy French wine into initialed styrofoam cups. I was still not

convinced that this man hadn't been sent from central casting. It wasn't until we were airborne and he had begun his barrage of predacious questions that I realized he was not acting a part.

After our pasture-to-pasture ride, the negotiators met privately, and then he was off. Helen and I turned toward home.

By this time I had learned that Helen's house in Cotulla is called "Casa Verde" and that her favorite color is green. By ten o'clock that night I'd learned something else. To follow Helen Storey is an exercise in exhaustion. She's geared at top speed. She does not consider "slow" and "stop" to be good time guidelines.

Helen's father, H. D. Storey, put Cotulla on the map by bringing thousands to town for his annual Fourth of July rodeo, one of the best in Texas. Cowboys came from all over to participate. They were roped up, pitched up, and stomped on. The audiences loved it.

In 1937, Storey brought 20 old trail drivers from all over the state, and furnished each one of them a horse to ride in the parade before the rodeo. Four thousand people lined Cotulla's streets to watch.

Waving from her horse was Helen, queen of the parade. Her lifelong friend, Hogue Poole, was king. There was no nepotism involved in her election. She was elected by folks in Cotulla, fair and square. The ballot box was downtown in the lobby of the picture show.

The trail-drivers' parade might have been the last full weekend Helen spent in Cotulla. Prior to our meeting I had spent many a quarter on phone calls talking to her maids, only to learn that "Miss Helen's out of town."

Where is she most of the time? Usually at a pigeon shoot. "I've shot all over the world," said Helen. "I shoot with the men." (One man forfeited to her, rather than lose to a woman.)

"When I was growing up," said Helen, "my brother and I had to look for things to shoot. I started out shooting tin cans and later graduated to rabbits and coyotes."

While Helen was at the University of Texas, her beau, Hogue Poole, called her from Cotulla to tell her his parents' home had burned. Helen's reply: "That joke's so old, it's not even funny. I'm hanging up now." The telephone operator, who found Helen and Hogue's conversations much more interesting than her view of Cotulla's streets from the upstairs telephone office, immediately called back Helen in Austin and said, "Helen, Hogue's house really did burn."

Helen recalled childhood tales of desperados and shootouts in the streets of downtown Cotulla.

"It was wild and woolly—I've heard this story all my life. One night, a man and his son checked into the hotel. They took a northwest room farthest from the street. During the night, the father didn't sleep much. Constant noise from the gunfire outside kept him

awake. At dawn, he nudged his son and said, 'Wake up. We're going out to bury the dead.'"

Rumors of Cotulla's high-handed escapades traveled fast. At Millet, a few miles from Cotulla, train conductors warned passengers to pull down the shades before entering town. Picking off passengers as targets on a moving train was an afternoon sport favored by gun-totin' sharpies. There were three additional stops in the western part of La Salle County: Tuna, Twohig, and Bueno.

Sunday morning, shortly after sunrise, a few church bells and a crying baby scattered tendrils of sound across what would be another intolerably hot day. It was time for me to leave. Helen followed me in her car to the only open service station in town and insisted that I fill up my car before heading for Corpus Christi. She handed me a plastic jug of water. How far away was Corpus, I wondered?

I hugged my charming new friend and said good-bye. Helen Storey was a character, one whose company I'd thoroughly enjoyed. As I drove out of the still-silent town and rounded a small curve a sign bid me good-bye: "Next service station 78 miles."

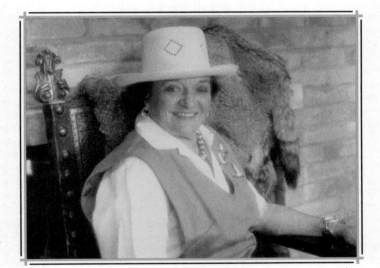

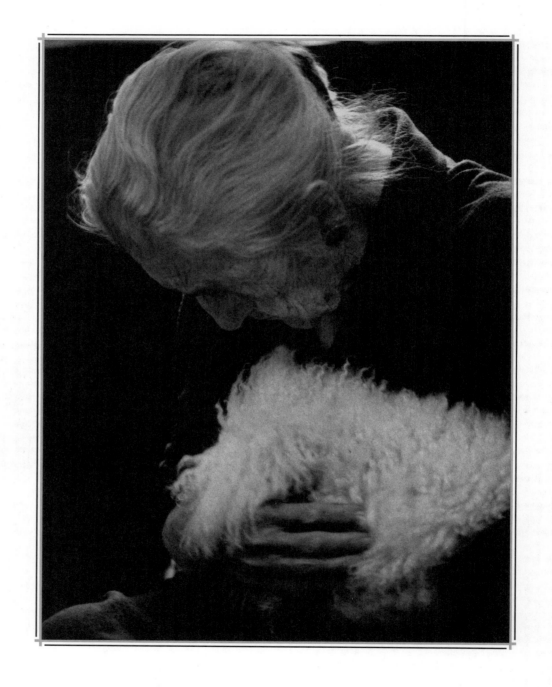

"Well, thank you. She was a prominent figure."

On being told she was like Scarlett O'Hara

Annie Lee Nance Storey
(1887-1983)
Storey Ranch
Near Cotulla

She was born on Christmas Eve in a log cabin on the banks of the Blanco River, feisty and full-voiced. Ninety-four years later she hadn't changed much. The perceptive Annie Lee Nance could read a man's eyes a block away and distinguish one with character from those who had none.

Her grandfather, Major Ezekial Nance, owned a 10,000-acre plantation through which ran a frisky portion of the Blanco River. Nance built a cotton mill and a grist mill, which he shared with neighboring farmers. A settlement grew around Nance's new venture. Some called it the Blanco Community. Others called it Nance's Mill. The year was 1854. Three years later, the scenic river turned destructive. A fierce flood wiped out both mills.

The ambitious and determined Nance challenged the river again, building a sawmill, a shingle mill, and a textile mill that furnished serviceable cloth to the struggling Confederacy. His efforts were destroyed in 1869 when the turgid river swelled again to a reckless rampage. Still, the tenacious Nance rebuilt.

In 1881, two-and-a-half miles away, the International and Great Northern Railroad rolled into the new townsite of Kyle. Nance

recognized an onslaught of opportunity. The town was barely two years old when he broke ground for his new cotton gin. Kyle prospered and so did Nance. The log cabin in which his daughter had been born was added onto and renamed "Three Oaks." The demure but strong-willed Annie Lee Nance was the unrivaled belle of the place.

Sitting in front of the fireplace in her home in Cotulla, Annie Lee Nance Storey gave her white poodle, Gee, a loving hug and a pat before he hopped off her lap. At 94, her alert eyes could still spot imposters and those who were "up to something."

"Every winter Papa killed over 100 hogs," she began. "They would salt cure the meat and smoke it over mesquite and oak and keep it in the smokehouse till we needed it. But the thing I remember best was my brother and I playing ball with a blown-up hog's bladder." (She failed to say who blew up the bladder.)

"There were parties—lots of them—and music and company and hunting for pot shards left by Indians who had camped on the place." Her blue eyes softened at the mention of Kyle. All events remotely connected with "the place" were utopian in her mind. Kyle was home, and it always would be.

Then came Cotulla.

"If I were going to hide from civilization, this is where I'd go," she said when she married Dudley Storey in 1909. Ten years later she left Kyle and moved to the ranch outside Cotulla.

"Lord have mercy, the first years were hard," she said. "That ranch was the most miserable place I'd ever been. I missed Kyle. We had servants there. On the ranch I did everythin—cooking, sewing, churned my own butter, took the ranchhands' dinner to them out in a pasture, and spent half my time washing smoked lamp chimneys.

"But I did love to cook," she said. "Our wood stove was in the corner of the kitchen. It cooked a lot better than the ones we have today. Dudley and I spent a lot of evenings around that old stove. Sometimes old Charlie or old Jack Harper or Pole Cat Wilson would come to the ranch. Pole Cat was a trapper who trapped varmints in the woods. Pole Cat had carved this jumping-jack thing that jumped when you pulled the string that was attached. Dudley and I laughed our heads off."

The independent blue-eyed belle learned to love life in the dusty, arid little town of Cotulla. Today, at the arrival of every South Texas sunrise, her driver, Tacho, takes her out to the ranch to check the cattle. Midday, Tacho parks the car in front of Cotulla's only grocery store so that Annie Lee can catch up on the town gossip. Then she embarks on her next-favorite pastime— delivering fried chicken to the sick. First stop: Dairy Queen. Tacho orders and then drives Annie Lee to the ailing folks so that she can deliver hot, crispy chicken like a queen bestowing jewels upon her subjects.

Gee walked back into the living room, followed by Annie Lee's daughter, Helen, who gingerly reminded her mother that last month her bill at the Dairy Queen had exceeded $160.

"Well, Helen," she replied, "I like to stay in touch."

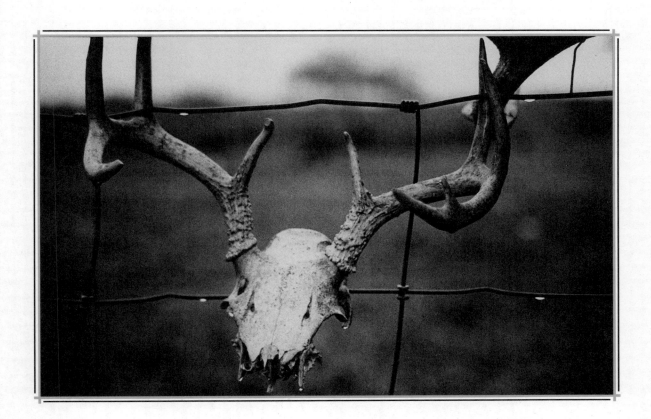

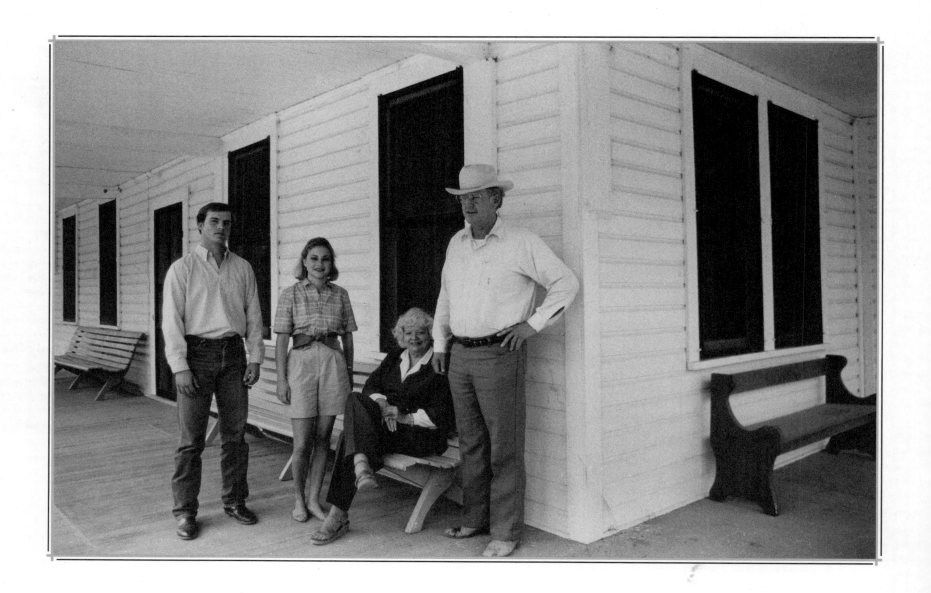

*"The country was primitive and hot as the devil. We used to
drive the cattle from Aguilares every spring. We'd winter 'em down
there. There was no water on the road to Aguilares, or even in town.
They'd haul water in on the Tex-Mex. Anyway, after the cattle had
been driven 25 miles, they were in a hell of a shape."*

Jim Donnell
Dull Ranch
Zella Ranch
Lowe Ranch
and Prince Ranch
Near Fowlerton

In khaki pants and dusty boots, tall Jim Donnell ducked when he
entered the doorway of his remote Georgian ranchhouse, located in
McMullen County, the least-populated county in Texas.

I followed him through a formal living room and into an
added-on den. Hanging on the dark-panelled walls were large
Audubon prints of skinny jackrabbits and wild-eyed javelinas. On
tables were prominent bronzes and nostalgic portraits of Jim
Donnell's pioneering ancestors.

The most determined-looking photograph in the room
was of Jim's great-great-grandmother, Melissa Jane York Lowe.
Lizzy, as she was called, was dressed in Victorian black with a clump
of frothy lace at her neck. Her face, square-jawed and crescent-
eyed, was a composite in fervent advance, like an arrow about to hit
a bull's-eye. None of those downtrodden, dispirited pioneer blues
for her.

Jim and Lizzy Lowe arrived on the banks of the Frio River
when the settlement was in its genesis. The Lowes began their new
life on the riverbank frontier that would evolve into a trio of names:
Dogtown, Colfax, and Tilden, the last of which it is called today.

In 1856, Lizzy spent her time spinning, cooking, sewing, churning, and raising six babies, while Jim branded the cattle that roamed freely on the open range. More than 100,000 head carried his brand. He never owned much land; instead, he depended on free grass and an unfenced world. Tough and fearless, for many years he prospered in the cattle business.

In addition to his horse and cow sense, Jim Lowe had the ability to make people laugh. One evening he and Lizzy were sitting in front of the fireplace when a bolt of lightning struck close to the chimney. He jumped up and hollered, "Gawdamighty! Gawdam my soul, Lizzy! Get me my gun, some S.O.B. just split my head open with an ax."

In 1870, Lowe's fortune turned. He was an honest man who trusted the tally books of the men to whom he sold cattle. He gave them permission to gather his cattle and count out the number that he'd agreed to deliver. The men he dealt with were frequently less than honest.

In addition, Lowe did not realize that in order to maintain himself as a cowman he must own land. He lost nearly everything. Later, when McMullen County was organized, Lowe earned his living by serving as its sheriff.

In 1881, two wealthy brothers from Pennsylvania bought 400,000 acres of land in Texas. Rumor has it that the Dull brothers traded land for enough steel rails to run the railroad from San Antonio to Laredo.

Ranching was as unfamiliar to the Dull brothers as thunderclaps were to Jim Lowe, but the Dulls did hire a seasoned ranchman. In addition to knowing the territory, Captain Lee Hall, a former Texas Ranger, also knew the law. He had settled the long-running Sutton-Taylor feud. The combination of his legal expertise and his ranching ability made him perfect for the task he undertook. The Dull brothers fenced in 230,000 acres of previously open range. It was the first ranch in South Texas to be enclosed with miles of cedar posts and barbed wire. Not everyone supported the decision. Hall dealt with those who did not.

Hall's wife was a cousin of writer William Sydney Porter, who is better known as O. Henry. Most of O. Henry's stories were written at the headquarters of the Dull Ranch, where no doubt Captain Hall's knowledge of frontier justice found its way into O. Henry's tales.

In 1901, the Dull brothers sold out to Brazilla L. Naylor and A. H. Jones, the men who built the St. Anthony Hotel in San Antonio. In 1911 Charlie and James Fowler purchased 100,000 acres of the land and founded the town of Fowlerton. The Fowler brothers promoted their "Frio Valley Winter Garden" as a "happy, healthy dream community." Rumor has it that at night the two brothers would sneak out and water the recently planted fig trees.

Later they would kick dry dirt over the damp earth, making it seem that fig trees flourished in an otherwise desert country.

Salesman from Fowlerton traveled to mining communities in West Virginia, Tennessee, Nevada, and Colorado, selling off ten-acre tracts in their newly found oasis. When a tract was paid for, the purchaser was issued a deed. Fowlerton grew to more than 2,000 people, and the town's pride was its three-story hotel.

It was impossible to make a living by farming a ten-acre tract, and the drought of 1917 wiped out any remaining hopes of these small farmers. Families pooled their life savings for a train ticket home.

Roy Lowe, Jim Donnell's grandfather, began buying up portions of the Naylor and Jones estates and blocking it up to create the nucleus of the ranch Jim owns today. Later, J. W. Donnell, Jim's father, continued to look up the owners of the small tracts and contact them for purchase.

Today, Jim Donnell still tries to convince the remaining heirs (who continue to hold out) that they need to sell.

"They all think they've got an oil well," said Jim. "I guess if you lived in Tennessee, you'd think that too. I've been contacting these people for the last 25 years. We telephone them regularly and keep in close contact. There aren't many left now. But in the past, it was like working a giant jigsaw puzzle."

As Jim and I visited in the den, his wife, Leighton, drove up after a 70-mile round-trip to the grocery store. Jim excused himself and went out to help her unload the car. Within ten minutes the house was popping with activity. Beryl Lowe Rice, Jim's mother, arrived from Marfa. Their daughter, Cydney, came in. Leighton's mother was in the kitchen making chicken salad. That evening, the Donnells' son, Jamie, would graduate from high school, and the unbroken line of ranchmen, honorable and worthy of respect, would continue.

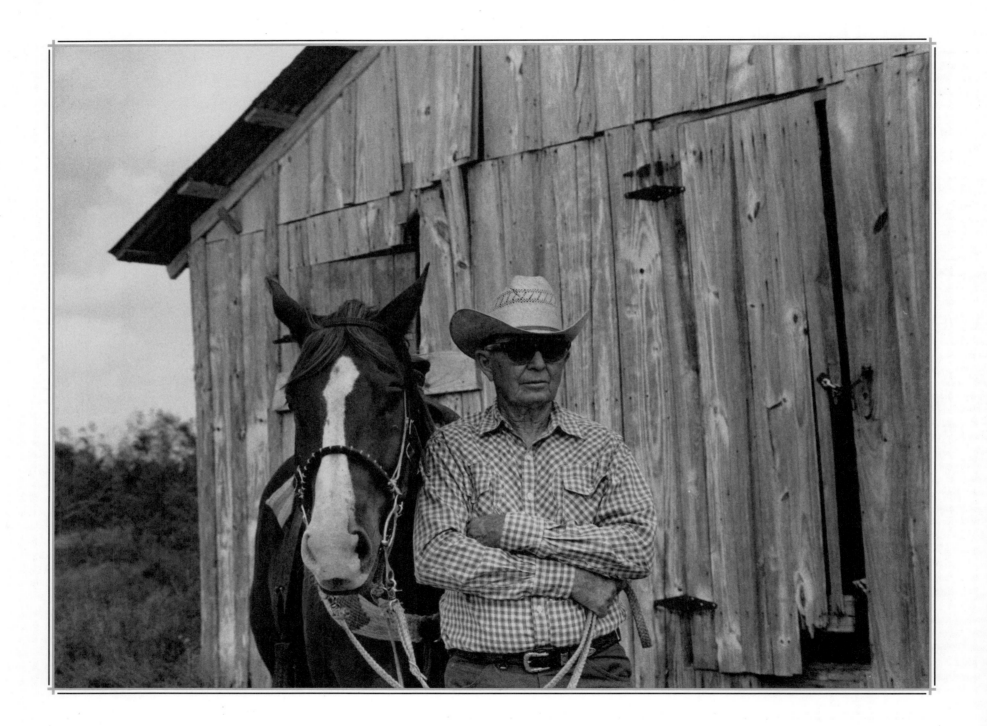

"I was team-roping steers once and got my finger caught in the wraps. I felt a jerk, looked down, and the end of my finger was just hanging there. The rope had pulled it clean off."

George Saunders
Mesquitosa Ranch
In Brooks County

iry disks of tumbleweed, dried the color of old tobacco, flew across the road. Dust kicked up by the wind veiled mesquites in illusions of gauze. In the distance a shimmery figure appeared on a horse and eventually came into focus. George Saunders climbed off his horse and tied him to the fence of his weathered corral.

"What's his name?" I asked, referring to the horse.

"Which name? He's got one name on paper."

"What do *you* call him?"

"Well, to tell you the truth, we call him Balls. But just say his name is Buck. He's gentle, though, and he really doesn't buck. Janice, my daughter, had him moved out here when she discovered he couldn't run. A snake bit him, and hell—he had so much venom in him, it'll take him forever to get well."

George Saunders is a wealth of South Texas tales, versions told to him by a vaquero who had worked for the Saunders family for a lifetime.

"My father was about 50 years old when I was born," he began. "He didn't tell me many stories, but an old man named Chico

Flores told me lots of stories about things that went on in this part of the country. I remember one about the Wild Horse Desert, which was all of this area around here. There were hundreds of wild horses running loose. In order to catch them, men on horseback would run the old mares until their colts would get tired. Then they would get between the mares and their colts with their saddle horses and move them all into a pen."

At age 70, George has seen or heard about important changes in Texas ranching and what it meant to be a rancher in the days when Mexican banditos made raids to the north. He watched the movement in this country from open range to ranching.

"After barbed wire came in," he said, "everyone got possessive. By the 1900s, everything was pretty well fenced-up. People had no idea how many acres it took to run an animal. There was a family that had a 16,000-acre ranch. They ran 4,000 cows on it, using natural water from ponds and creeks. They had wells, but no windmills. The drought killed almost everything they had—the cattle starved to death. The fact is, there is still no exact set amount for how much land you need to run cattle."

South Texas was still pretty wild when George's father was growing up. Lum Saunders was the last survivor of a bandit raid in Nueces County. At the time, he was living in Banquette, an important crossroads for trade with Mexico, when thugs came up from Mexico and raided the store of a man called Noah.

"Now, old Noah was pretty cagey," George recalled. "He had built an underground tunnel that led him out of the store. The rest of the customers, including my father and grandfather, were marched out to some stone pens where they were kept while the raiders burned the store. They had set my father, a toddler, up on one of those big-horned saddles to take him to the pen. When they got there, they tossed him off. It's a wonder he made it.

"According to my father's story," George said, "the bandits took $500 from his father—you know, they traded in gold in those days. They also took his pistol and buggy horses. I still think those bandits were displaced Mexicans who wanted to take back the land the gringos had taken from them."

Buck, a.k.a. Balls, squirmed and shifted his weight. George gave him a slap on the backside and the conversation turned to horse racing.

"We got into it kinda by accident," he started. "We had a couple of mares to breed, and when you use a horse on cattle, speed is one important consideration. So when it came breeding time, we took the mares to this stud down in the valley who had a terrific bloodline and a reputation for putting speed on his colts."

After the colts were born and were edging into their second year, a man at the riding arena suggested a trainer to George. "Until then, I hadn't known that Lupe was available, but we got him and he started riding the 2-year-olds. One day I asked him,

'Lupe, can that mare run?' 'We can try her,' he answered. So he ran her, and she ran an 80 index. You know, if they do that, they're listed in the Quarter Horse Registry of America. From that start, we now have three or four horses that we race around here and sometimes in Laredo and Goliad."

It was time for me to go. George unsaddled Balls and hoisted his heavy saddle up on a hook in the barn. Horsemanship, cattle raising, and personality go way back in the Saunders family and don't show signs of coming to an end. Before George led Balls back to the corral, he said in farewell, "Get your butt gone, girl, and don't have any wrecks."

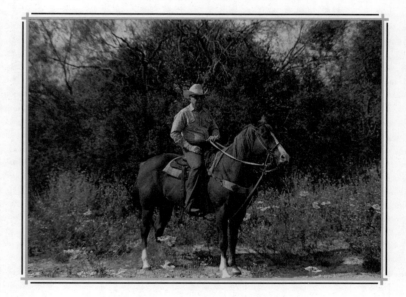

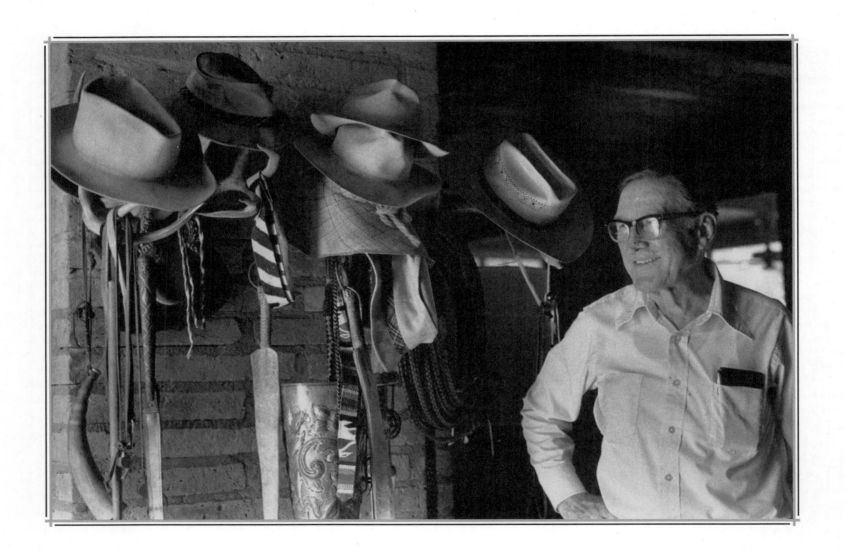

"When Caroline's mother, Mrs. Kampmann from San Antonio, first came down to the ranch, I told her, 'Mrs. Kampmann, if you compare this to a country home or a French chateau, why, we've got a long way to go, but if you compare it to a cow camp, well, we've come a long way.'"

Garland M. Lasater
La Mota Ranch
Near Falfurrias

From the O'Neal Ford-designed ranchhouse, Carolyn and Garland Lasater watched the beginning of a long-running afternoon ritual. Wild turkeys ambled in from the still-sunny prairie, seeking the coolness of an ancient live oak motte that surrounds La Mota and gives it its name. On branches shaped by a distant gulf breeze, the turkeys would roost until morning.

The enclosed back porch overlooking the grove was an ideal place for observing the strut and pomp of the wildlife and pursuing an art both Lasaters have mastered: conversation. Guests stimulated by their host and hostess explore subjects from Shakespeare to cattle rustling before moving into the dining room. Dinner is a formal occasion for which guests are asked to dress. This personal elaboration is adhered to nightly by the Southern-voiced, Sarah Lawrence-educated Carolyn. The formality is one not observed on most Texas ranches.

Andover and Princeton failed to remove the far reaches of the South from Garland Lasater's voice. Garland's steady countenance is a beguiling mix of "El Patron" and straw-hatted plantation owner.

Child rearing at La Mota was affectionate doses of hugs and pats doled out in an intellectual atmosphere; Carolyn and Garland's efforts resulted in a family of five articulate adults who speak prep-school Tex-Mex and genuinely like each other. Eastern schools did not remove them from their roots, nor did it remove their enviable closeness.

I met Garland in downtown Falfurrias at his office in an unpretentious building that houses the financial operation of Falfurrias Creamery.

Garland leaned back in his swivel chair and said, "Dad was a trail blaz-a-h-h-h-r," drawing the word to South Padre and back. "He first saw the grove of live oaks at La Mota in 1893. They were an oasis in this dry prairie country and important enough to be listed on early Spanish land grants. They were referred to as La Mota de Falfurrias. In the Lipan Indian tongue, the word Falfurrias means 'land of heart's delight.'"

Garland went on to explain that a terrible drought had caused financial panic, especially for the Mexican ranchmen who depended on shallow wells to water their cattle.

"Dad was engineer enough to know there was water in the country if wells could be drilled deep enough, so with the backing of his banker, Dad made a gold bid for the potential empire he saw in Texas. He had faith in the country. His faith was rewarded. By 1900, the ranch had grown to 400,000 acres—one acre larger than the state of Rhode Island. With his revolver strapped to his side, he could ride the ranch three days and not see a soul."

Edward Lasater's dream was to breed range cattle that would require little attention. He crossed Brahmas with shorthorns and Herefords, resulting in the heat-resistant Beefmaster. But he still had the problem of getting his cattle to market without driving the weight off them on the trip.

"Dad needed a railroad," Garland explained. "The small village on the ranch, consisting of a few adobe jacals near Laguna Salada, was not suitable, so Dad and a few friends rode out in search of a town site. On a hill five miles east of La Mota they saw a coyote. His shrill cry protested their presence. 'We'll build the town where that coyote is,' they decided."

In 1902 the San Antonio and Arkansas Pass Railroad extended its line 186 miles to Lasater's holdings. At the end of the line, a freshly painted sign read FALFURRIAS. Shortly after the railroad chugged through the new town, Edward Lasater imported a trainload of Jersey cattle, turned 40,000 acres of his land into a series of dairy farms, and founded Falfurrias Creamery. Today, the most noble and lasting result of the dairy is a product that continues to glorify baked potatoes all over Texas: Falfurrias Butter.

Edward Lasater's ranch was not spared by the Depression. Much of it was lost.

"Dad borrowed a lot of money to buy the ranch," Garland

said. "He also spent a lot of money on the dairy. The combination of the two plus a faltering cattle market got him down.

"We're still here," Garland added, "and as some of the old Texas maps describe, 'right in the heart of the Wild Horse Desert.' I like to wonder what it must have been like when the mustangs roamed this area.

"The ranch isn't as large as it used to be. We only work cattle about three times a year. But when I'm out in a pasture working cattle, well, those are the days I consider peak."

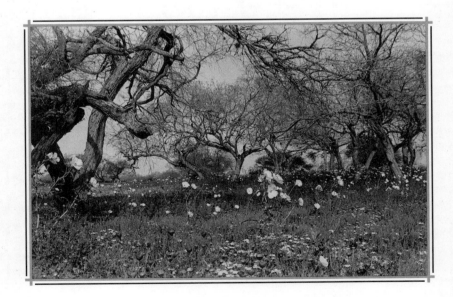

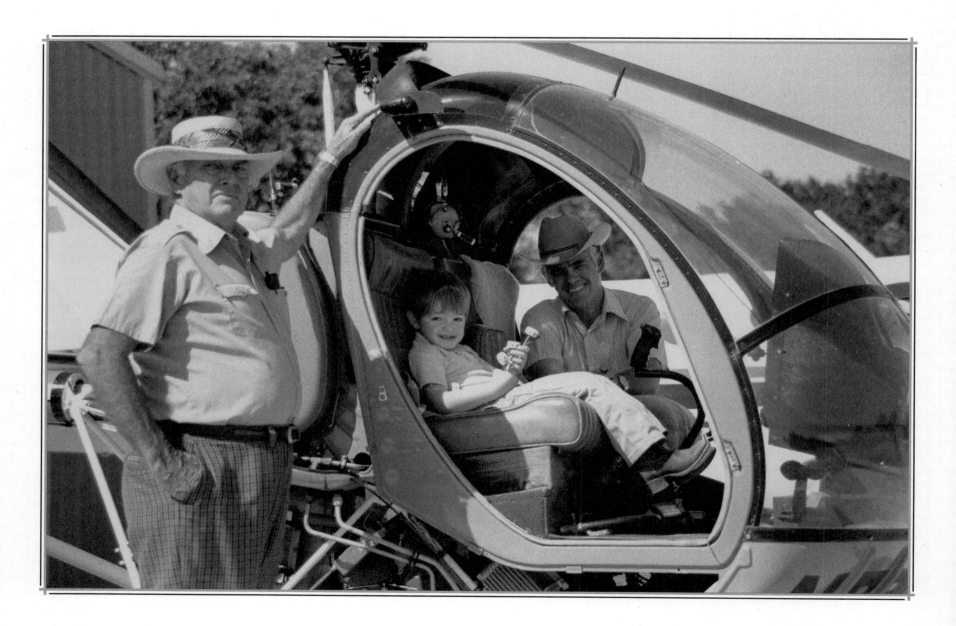

"It would be virtually impossible to start now without an inherited ranch—my father paid $6.50 an acre for this ranch. In South Texas, no one ever sells. These ranches have been down here for generations. I see no chance of them ever breaking up."

Dick Cage
(1909–1988)
La Calosa Ranch
Near Falfurrias

At his home near downtown Falfurrias, Dick Cage cooled himself in his dimly paneled den. Outside, the caliche dust blew like snow in the 102-degree heat. At first, he seemed lofty and impervious. But after the obligatory weather chat, Dick's personality warmed and showed a lively intelligence, fueled with dapper manners and a sense of humor. The tall, white-haired man with a distinct posture and a matching ranching heritage started the conversation.

"In 1925, my father bought 50,000 acres from Ed Lasater. In 1930, he bought another 30,000 acres," Dick began. "He wound up with 80,000 acres. The land was part of an old original Spanish land grant called the Vargas. In 1930, we moved our ranch headquarters to an old windmill called La Calosa [Limey]. It's been La Calosa Ranch ever since."

When the elder Cage bought the ranch from Lasater, it came stocked with Brahma cattle imported from India.

"But Dad liked Herefords," Dick said, "so we sold the Brahmas and started raising Herefords. We wanted a larger calf at weaning. We were tired of fighting pinkeye, so we later switched to

crossbred cows. Our goal was to market a calf that weighed 500 pounds at weaning. We were successful. Later, I experimented by putting a certain breed of bull in one pasture, and another breed in a separate pasture, all on Hereford cows. I got the size of calf and the quality that I was looking for. It was a rewarding experience."

Dick's thoughts turned to a time that wasn't so rewarding, back in the '30s when he sold calves for $20 apiece.

"We sold the same type of calf in 1979 for $500. At the time, I worked on the ranch for my father. My salary was $100 a month. When I married Julia and brought her down here, we had no electricity," he recalled. "My wife, who had never fried an egg in her life, did all her cooking on a wood stove. She also churned all of the butter we ate. Saturday nights were our reward for a week of hard work. Julia and I went to "Mothers Cafe" ten miles south of town. There was a nickelodeon that never stopped playing and you could buy three bottles of beer for 25 cents. You could have all the fried chicken you could eat for 35 cents. Our entire evening's entertainment came to one dollar apiece, and we had a grand time."

Julia Cage grew up in Alice, a town a stretch away from Falfurrias. Her grandfather, P. A. Presnall, lived in Langtree, Texas, where he was the county treasurer and was in office at the same time as was Judge Roy Bean.

After graduating from Southern Methodist University in Dallas, Julia Cage divided her time between San Antonio and Corpus,

promising herself two things: she would *never* under any circumstances marry a man whose livelihood depended on the weather, and she would *never* again live in a small town like Alice.

But Julia married Dick Cage and moved to the ranch. "Town" (Falfurrias) was 15 miles of sandy roads and three gates away. Corpus was another 90 miles.

"Our link to the outside world was our party line," Dick said. "Five rings was our ring. We lit our kerosene lamps at dusk, and our only concession to modern living was indoor plumbing. Julia's idea of luxury was lots of ice and painting the floors once a month."

Dick asked me if I wanted to see the ranch. Fifteen miles later, we arrived at the entrance to La Calosa. Dick opened the gates with his electronic gate-opener. One quick glance told me that Julia's floor-painting days were over for good.

A house, hidden behind a mass of cluster oaks, mirrored an architect's rendition of a Spanish mission. "That's where my son and his wife live," Dick said. "They're expecting us."

Water dripped and bubbled over mossy-green fountains on the patio. Visually it was Barcelona. A handsome, prematurely gray Presnall Cage opened the door of his sophisticated hacienda under the oaks and invited us in. Noises of babies and floor-buffers commingled. Presnall showed us through the house. He pointed out the mesquite floors made from trees grown on the ranch. The wood

had cured for ten years before being cut up and mosaicked onto the floor. "It has to be really dry before you lay it, or it will warp. To me, it's pretty nice to have a part of the ranch on the floor," Presnall said.

A squawk box in the den bleeped "Unit two, unit two." Presnall answered, "Unit two here." There was talk of cattle. Presnall excused himself and left.

"My son actively manages the ranch now," Dick said. "I just kind of let him operate it. Every now and then, I'll throw in a suggestion, but half the time it's ignored. All of us still like contributing a little bit of something once in awhile."

Dick and I got in the car and drove to the hangar that houses the family planes. We stopped briefly, and three generations of Cages posed for pictures. When we left, Dick could hardly contain his love and affection for his son. "That boy got his pilot's license at 16. He flew in Vietnam and was awarded the Distinguished Flying Cross. He was a flight instructor at Laredo Air Force Base and also in San Antonio. But he always came home to the ranch and his first love—cowboying."

Not far from the hangar was a more modest house that belonged to Dick and Julia. Parked in front was Julia's custom hunting car built for her by her son-in-law, George Montgomery of San Antonio, and called "Captain Nemo" because it looks like something from outer space.

Hunting in South Texas is a social expression ranging from subdued to outrageous, but never eccentric. (Those kind of people live in California.) A weekend hunt in South Texas is a coveted invitation. No one described guests arriving for a weekend hunt better than did Julia Cage in her book, *The Care and Feeding of Hunting Friends*:

Two hours after their expected time of arrival you see dust down the road. You run out to meet them as their cars drive up. Much squealing, kissing, hugging, and glad cries. Every car is jammed to the ceiling with suitcases, duffel bags, guns, ammunition, coats, sweaters, game bags, boxes, and every kind of hunting equipment that Abercrombie has in stock.

The unloading and dispersing of this luggage requires a task force of at least three men (2 cowboys plus 1 houseboy).

Now begins the preparation for the hunt. This requires about an hour, as they must change into hunting clothes and find those boots that are always out in the car, on the porch, or have been left behind.

After everyone is ready, serve a round of drinks, as you must wait for that last couple who have not arrived. The following remarks will be made:

"I hope we get in a little hunting this afternoon."

"I had planned on killing my turkey today."

"Where can they be? They left an hour before we did."

"Some people are so inconsiderate!"

"Can't we go on and come back after them?"

Try to keep them calm, as the last guests will arrive soon. No one has ever failed to show up.

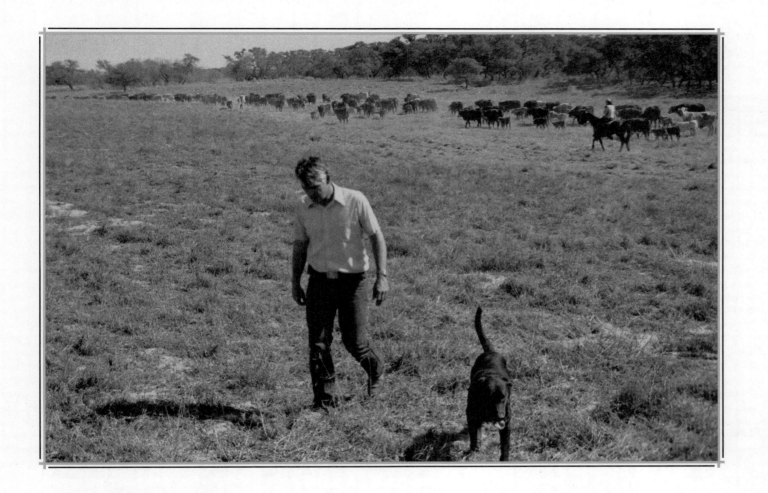

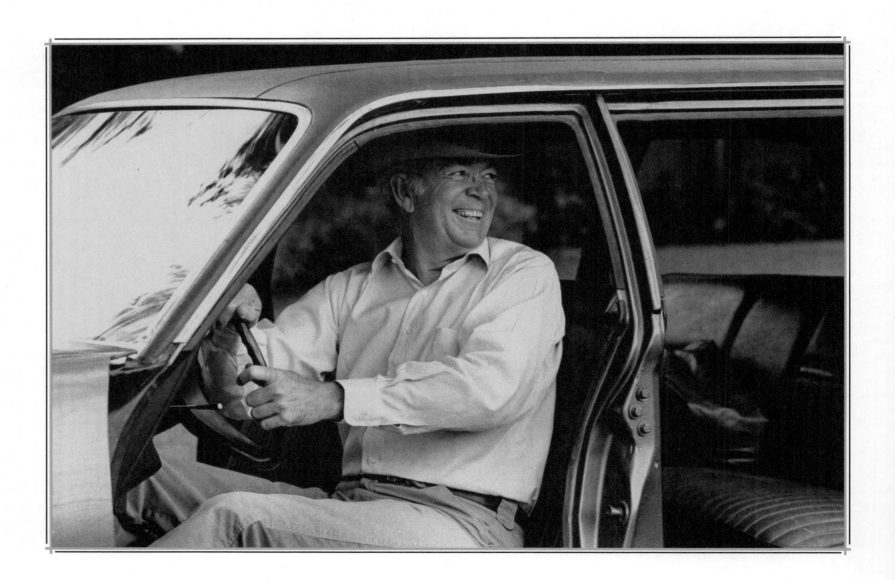

"The press was most cooperative. One publication violated the rules by renting a fancy Rolls-Royce. They drove up to the gate and insisted that they were members of the family. They were from the magazine and the newspaper named "W." The poor gateman was so overwhelmed by the fancy vehicle and their insistence that he let them in. Fortunately, Garland Lasater and I were nearby when they drove in. Garland, of course, is as big as I am. I said, 'Garland, get rid of those people for me. They're not supposed to be here.' Garland approached them in an ominous sort of way and directed them to the proper entrance for the press. They turned tail and ran."

On the visit of Prince Charles

Tobin Armstrong
Armstrong Ranch
Near Armstrong

common characteristic among Armstrong men is their state-of-the-art "Texas look"—tall and blue-eyed with bones chiseled Marlboro thin. They are handsome men whose predecessors "dealt with" before being "dealt to." The strength of the progeny did not escape Tobin. His lineage, profound and free from weakness, goes back to the Alamo.

An ancestor of Tobin's, John William Smith, fought in the Battle of Concepcion and at the Siege of Bexar, where he accompanied Deaf Smith on assault parties. When Santa Anna approached San Antonio de Bexar, Will Smith was selected by William Barrett Travis to dispatch the last message from the Alamo.

Tobin's grandfather, John B. Armstrong, was an officer in McNelly's Rangers. He earned the name "McNelly's Bulldog" after capturing two of the most wanted men in Texas.

The best-known of the outlaws was 25-year-old J. K. "King" Fisher, a tough cattle rustler with 12 notches carved on his pearl-handled revolver—one notch for each man he had killed. Frequently Fisher fled from lawmen while wearing his customary white sombrero, a black jacket embroidered in gold thread, a bright-

red silk sash across his middle, and tiger-skin chaps. By frontier standards, the desperado's dressing habits were a bit wacky.

Armstrong and a group of Texas Rangers caught Fisher and nine of his men.

Armstrong's greatest exploit was capturing the worst bad man Texas ever produced, John Wesley Hardin. Hardin could draw his pistols with lightning speed and put 12 bullets in a playing card at 20 yards. He killed 45 men in a ten-year span, including one who dared to snore too loudly in an adjacent hotel room. Hardin killed him with one shot through the wall.

Because of Hardin's deadly escapades, both Texas and Louisiana offered a reward of $4,000. A thousand self-appointed deputies set out to find him. Not surprisingly, Hardin dropped out of sight. John Armstrong also found the case interesting. After the Rangers gave him the OK to pursue Hardin, he and fellow ranger John Duncan set out to find the most dangerous man in Texas. Armstrong was determined to bring him back alive.

The year was 1887. Armstrong boarded a train in Pensacola, Florida. Duncan spotted Hardin sitting next to a window on the station side. There were four men with him. Hardin saw Armstrong's long-barreled Colt .45, shouted, "Texans, by God!" and went for his six-shooter. A sidekick of Hardin's opened fire, piercing Armstrong's hat. Armstrong returned fire, hitting the man in the heart. Meanwhile, Hardin fumbled for his own gun, which was caught in a suspender strap. Armstrong whacked him in the head with his seven-inch barrel and knocked him out cold. The three remaining gunmen surrendered to Armstrong, and the reward money from that shoot-out became the genesis of the Armstrong Ranch.

John Armstrong's grandson, Tobin, may not have captured bad guys or ridden through a battlefield dodging shrapnel, but he did not disappoint historians. In keeping with family tradition, Tobin Armstrong created his own niche by being the first rancher in Texas to entertain the future King of England.

Getting ready for the Prince's visit stretched improvise and makeshift to new heights. From a dusty pasture, Tobin created a polo field, and from another, an airstrip, causing the Prince to later quip, "There's more equipment on this ranch strip of yours than on practically any RAF base in England."

John William Smith and John Armstrong dodged bullets. Tobin dodged deadlines.

In Tobin's words, "Anne and I had just returned from Great Britain. We were in San Antonio for the Scotch Order, a ceremony held up there in the spring at the Alamo. While we were there, the British Consul approached Anne, who was Ambassador to the Court of St. James. He said that he had heard from Buckingham Palace, and the Prince was going to be in the United States on an official visit. He would be in Texas and had expressed an interest in visiting our ranch. This was in 1977, and we were right in the

midst of completely renovating our house. In fact, the house was completely destroyed. Anne and I discussed it and decided that we would be happy to have him come, the only problem being there was such a short time-fuse on our preparing for it. The Prince would arrive in October. It was then the end of June.

"The procedures, well, you wouldn't believe. Who's going to be on the guest list? Everybody and his brother wanted to be here for the affair. The Prince had expressed interest in playing polo, so we decided that the way to handle it was to have a big affair at the polo field, transporting the guests out there without them getting into the residential area, where we would later have a smaller, more intimate group of family, ranch partners, and our closest friends."

Responsibilities were assigned to other people for certain aspects of the visit—the only way to handle the monumental task. Friends pitched in to solve the transportation problem, aviation problem, entertainment, food, and so on.

"We had to build a road into the polo field," Tobin said. "We didn't want it to look like it had just been built, so I went out on horseback and designated the path that we'd follow. We wanted the passageway just wide enough to accommodate a horse van. Anne was on the Board of General Motors, and General Motors agreed to let us have these recreational vehicles. They sent six of them. They also provided a place for the ladies to go 'powder up.'

"We had the press come well ahead of the Prince in order to get an understanding of the ground rules. They were most cooperative.

"The night before the Prince was to arrive, we got a call saying that the Prince would like to see a roundup. I said, 'My God, we've got a polo game going, we've got everything else, how can we have a roundup?' So I said, 'If he wants a roundup, we'll give him a roundup.'"

The next morning Anne and Tobin went to the Naval Air Station in Kingsville. After the Prince was met with a military guard and red carpet, they put him into their car and proceeded into Armstrong.

"As we approached Armstrong," Tobin recalled, "you could see there was a terrible prairie fire. All our freshly mowed grass had dried and been set on fire by the catalytic converter on the deputy sheriff's car. This was just at the entrance to the ranch, which caused an interesting situation. There was no serious damage done, but it was a bit unnerving. We had enough problems without having to worry about a prairie fire.

"We brought Prince Charles to the house first. I presented him with a pair of boots to play polo in. He changed, and we drove back to the main entrance of the ranch for the roundup. We put him on a cow pony, and Anne and I joined him on our own ponies.

"We rode out to inspect the cattle which had been gathered for the occasion. While we moved toward the cattle the press people were right behind us with their cameras clicking away. The cattle were getting terribly nervous. I turned to these 30 photographers and said, 'Now I want you all to understand, I want you to get any kind of pictures you like, but if you proceed to follow up to the herd, well, these are range cattle and they'll stampede.' They held back for a short while, just long enough for the Prince to ride around and speak to the cowboys. When he turned back around and rejoined Anne and me, the photographers started clicking away. The nervous cattle charged and stampeded off into the brush. It was really funny.

"Then we got down from the cow ponies and got into a hunting car with my uncle, Major Armstrong, and drove down the trail to the polo field. You couldn't tell by looking that anything had been done to make this road. It looked like it was natural."

Around a corner of the brush and out in front of the entrance was a big clearing with yellow- and white-striped tents and flags from both countries. There was a Texas barbecue and mariachis playing and horses tethered along the fence-line on the opposite side of the field. The Prince changed in one of the recreational vans, familiarized himself with his horse, and then galloped down to where the press were and let them take pictures of him on his polo pony. "We gave them every opportunity they wanted, then they were provided with nice transportation back out to the highway, and that was the end of the press coverage," Tobin said.

"The polo teams were people who had made a real contribution to polo in the state: Will Farish of Houston and Kentucky, Bobby Beverage from San Antonio, Norman Brinker from Dallas, Steve Gillis from San Antonio, my brother John, my nephew Charlie, and myself.

"After the game, 37 aircraft took off. In a matter of three hours there were an incredible number of landings and take-offs for a little ranch strip like this. The FAA people gave us full cooperation."

Tobin and Anne had a small dinner party that night with a select group of friends and family. There was music and a little dancing. They tried to be creative about the table arrangements. Rather than have the Prince sit with the old folks, they got clearance from Buckingham Palace to have him sit with the young ladies, as long as Anne sat at the table with them. "We put the daughters of all of our friends who couldn't come at his table, so we surrounded him with all of these good-looking young ladies. At eleven o'clock, he stood up and excused himself and went to bed. At that time, everybody else got up and went either to their bedroom here or to the temporary motorhomes parked out in the back with electric outlets run from the main switchboard in the barn. Every room on the property was in use. Some of the family stayed at Norias, a division

of a neighboring ranch. The Prince hadn't been in his room for 30
minutes when the heavens just opened up. It poured down rain. We
were delighted. The party was over, everything was secured. We had
a wonderful rain to celebrate."

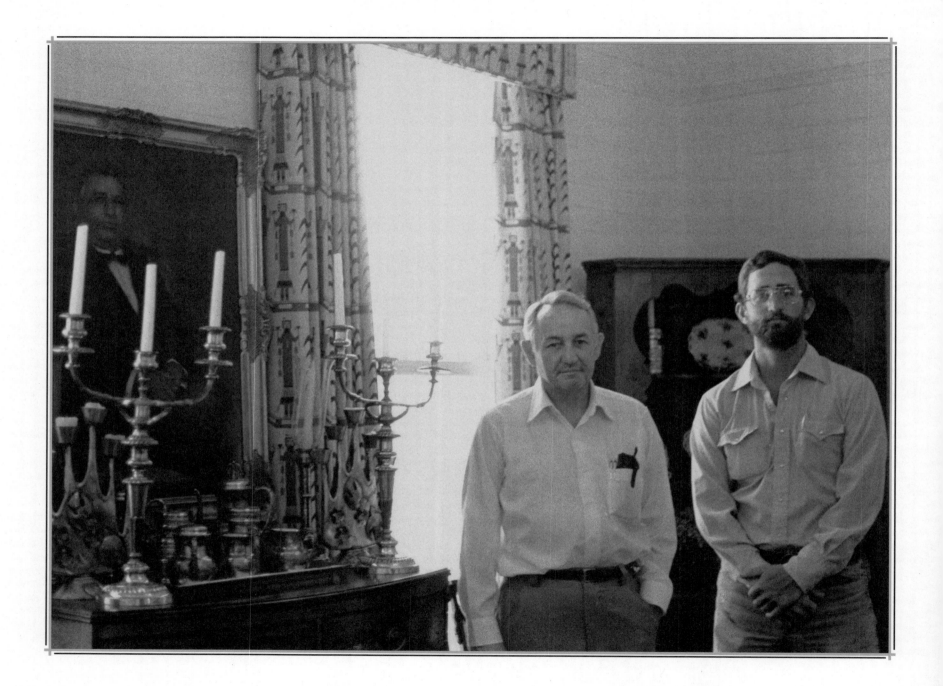

★ LEO WELDER ★

"This was a country where a man could be a man, and a good man could make himself a king."

T. R. Fehrenbach
Lone Star: A History of Texas and the Texans

Leo Welder
Vidaurri Ranch
Near Victoria

There was a reason Leo Welder's forefathers migrated to a country of buckskin, Comanches, and a sweep of frontier rascals. It was land—the common denominator that bound his earliest relatives, who fought Indians, cholera, and the raw adversity of an infant frontier.

The Welder family history is one of cross-geographical disciplines and overt tenaciousness that stretches across three continents. It is a story of fortitude among ambitious men, whose distressingly long struggles continue to reward the Welder progeny today.

In the late 1700s, Don Felipe de la Portilla came to Matamoros, Mexico, from his home in Burgos, Spain. In the United States, Thomas Jefferson instigated the Louisiana Purchase. That hit close to home in the Spanish government of Mexico, since Texas was Louisiana's neighboring state.

Hoping to avoid an occupation in Texas by people from Louisiana, the Spanish government wanted to establish its own settlements in Texas. Don Felipe was chosen to head one of the earliest ventures inaugurating the *empresario* system in Texas. For

this service, he was rewarded with premium lands. Don Felipe also had the good fortune to marry Maria Ignacio de la Garza, whose family owned abundant lands on both sides of the Rio Grande.

When Mexico won its independence from Spain, the government was anxious to develop and populate its frontier provinces. Texas and Coahuila joined together to attract land agents, or *empresarios*. Each *empresario* would receive 23,000 acres of land for every 100 families he brought in as settlers. Each family was granted 177 acres to farm, and 4,251 acres on which to raise stock. Most chose cattle.

The promise of land was overwhelmingly attractive to James Power and James Hewetson. In Mexico they sought the advice of Don Felipe. The two formed a partnership in 1826 to bring colonists from Ireland to Texas. When they returned to Texas they founded the Irish colony of Refugio and eventually became the largest landowners north of the Nueces and two of the wealthier men in Texas.

Historians have pointed out that Power's "Texas Fever" seemed more intense than Hewetson's. Perhaps the time that Hewetson spent living in Moncolva, Mexico, may have dimmed his memory of the atrocities the Irish were suffering.

The British government turned its head while thousands died in the famine of 1817. There was a burgeoning population explosion, and Catholics in Ireland were not allowed to own land.

What man would refuse to save his fellow countrymen from tyranny and starvation, and at the same time receive 23,000 acres of premium lands for every 100 families he brought over to challenge a new frontier?

Power's marriage to not one, but eventually two of Don Felipe's daughters brought him even more land, plus a sizable dowry.

Some years after his marriage to Don Felipe's daughter, Dolores de la Portilla, James Power prepared for his long voyage to Ireland, where he confidently expected to recruit the bulk of his colonists. Mrs. Power was pregnant and could not make the trip. Power arranged for passage to New Orleans on a vessel that had anchored off Aransas Pass. After the vessel had weighed anchor, a man on a horse was seen on shore frantically signalling to the vessel. The captain sent a small boat to shore to find out what the trouble was. The boat returned to the ship with Power's brother-in-law aboard. He had come to tell Power of the birth of a son. Power tried to cancel his trip. The captain refused to refund his money. Not knowing when another vessel would sail and not wanting to lose the passage money, Power sailed for Ireland. He did not see his son until a year later.

Power's voyage was successful. He recruited colonists by handing out handbills and advertising for people in Ireland to move to Texas. Most of them had never heard of Texas, but the idea of owning their own land was appealing to them. In order to escape

possible future famine and tyranny by the British government, 350 recruits signed up for Power and Hewetson's Irish Colony in Refugio. This pleased the supreme powers of Mexico, whose thoughts of a colony composed of native Mexicans and native Irish devoted to the common religion could not be questioned.

The first boat of colonists left Liverpool, England, on December 26, 1833. Bad weather forced it back, but it set sail again on January 3, 1834, and arrived in New Orleans on April 23, 1834.

Upon arrival at New Orleans, the colonists continued to headquarter on the ship for two weeks before they were transferred to two schooners that would take them to Aransas Pass. En route, both schooners rammed a sandbar and were stuck until dislodged by a heavy sea. One of the schooners eventually capsized, and its passengers were put ashore on St. Joseph's Island. Others stayed aboard the remaining vessel. Power took a sailboat to El Copano for help.

Meanwhile, cholera broke out among the colonists. Two hundred and fifty died and were buried at sea. By the time the colonists landed at El Copano, only eight had survived.

Franz Welder, his wife, and two sons landed at El Copano Bay in 1833 as members of the Beals and Grant Colony. Franz, formerly of Bavaria, Germany, traveled by oxcart to a settlement named Dolores on the north bank of the Rio Grande. The Texas settlement had been granted to Jose Vasquez Borrego by Jose de Escandon for maintaining a ferry-crossing on the Rio Grande. Dolores was located about 30 miles below present-day Laredo and was an important crossing-point to Texas settlements.

Indian raids, drought, and seasons without crops led to the failure of the settlement. The Welders left and returned to Matamoros, where Mrs. Welder died.

In May of 1836, Franz Welder and his two sons, John and Thomas, landed at Black Point on Copano Bay. They established a ranch near the home of Colonel Power. A few years later, John Welder married Dolores de la Portilla Power, the eldest daughter of Colonel Power. The legend continued.

It was noon on the Vidaurri Ranch. The spring air was bright and delicate, with none of the Gulf's foul mugginess. The great-great-grandson of James Power waited for me in an office a few feet away from the house built by his grandfather. Rawhide chairs sat around Leo Welder's office, worn and manly. A few men in chaps and spurs sat on a leather sofa discussing the morning's roundup. Leo had just driven to the ranch from Victoria, 20 miles away. His countenance of soft-spoken authority identified him as the man in charge. The ringing of an old-fashioned dinner bell interrupted our conversation about the truck traffic on Highway 59. We walked over to the camp kitchen a few yards away. Lunch was a five-star event.

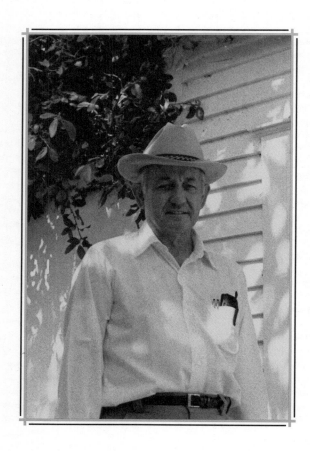

A large maple lazy Susan was filled with platters of T-bones, steaming bowls of pinto beans, spring onions, marinated salad, Spanish rice, sliced tomatoes, homemade biscuits, iced tea, and German chocolate cake. Two maids refreshed iced-tea glasses every few minutes.

All the men at the table had been working cattle that morning. Their spurs jingled when they got up to help themselves to seconds.

After lunch, Leo and I walked to the clubhouse—a complete house converted for the use of the family—and I asked him what the advantages were of being a fifth-generation member of an early Texas family. "Well, maybe it's the old thing of who got here first," he said, "but the one advantage of having this ranch in the family so long—it's a pretty good incentive to keep it going. The longer it stays together, the harder you work to keep it going.

"You know, people have gone broke in the cattle business," Leo said. "For one thing, it's not the greatest money-maker in the world, and farming can be pretty marginal at times. Then there are the divisions—more people, more heirs, and sooner or later some want to divide, and of course, that's their right. Division means smaller tracts that are much less economical to operate. The history of the people who have divided a lot is that most of them are not around any more. They end up selling for one reason or another. For instance, maybe a woman marries someone who doesn't really know about the cattle business. It sounds glamorous to them, and they think they are going to make a pile of money, but they make a few mistakes. Then they owe a bunch of money. Next thing you know, the land's gone.

"Another problem with dividing the land is, 'Whose piece is whose?'" Leo said, adding, "There's always the feeling that 'I got robbed.' Everyone feels that way, and that's a problem. Division is always a threat."

Leo spent his youth on the ranch. The land was called "Kyle Community." Neighbors were kinfolks. There was more to the town then—a big old store, a post office where people voted, and a hotel. A train stopped regularly.

"There was no highway then," Leo remembered. "Once you got good roads, there was no reason to stop there. The community had outlived itself. We didn't get to town very often. The train brought in staples, but we did a lot of our own things. We had chickens and eggs, and milk-cows, and we cured and smoked our own meat, and you did a lot of canning and preserving back in those days. We dried a lot of fruits. We'd put water on them. Use them like dehydrated products now."

"Did food taste better then?" I asked.

Leo responded, "Well, you like to think it did."

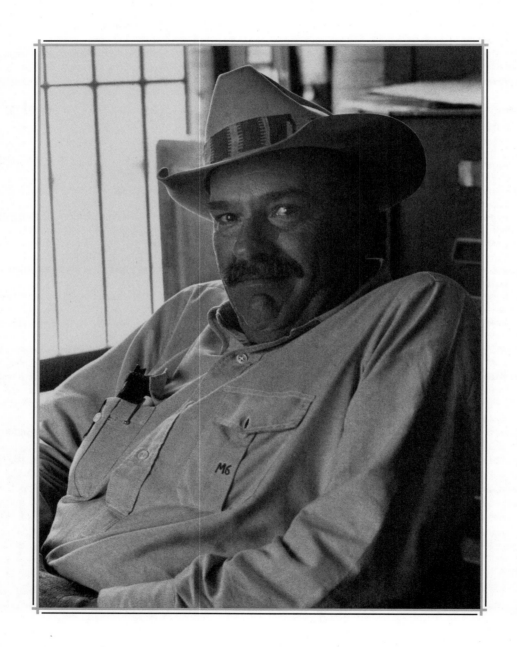

"Any position of responsibility is a lonely one—like the head of a company, or general of the army. It is also a fact of managerial life."

Kerry McCan
McFaddin Ranch
In McFaddin

In a room crowded with Stetsons, Kerry McCan's colorful Guatemalan hatband separates him from the crowd. His pants tuck in at the knee of his custom boots, and the McFaddin brand, registered in the 1840s, is embroidered on his shirts. His jackets, soft and distinguished with wear, belonged to his father, Claude. Kerry's urbane attire does not reflect the fact that he carries the habits of thrift to a fine persuasion.

On the coastal prairie countryside, 20 miles west of Victoria, the McFaddin Ranch, preserved for six generations, has not changed much since its founder, James, set up housekeeping a mile from the navigable Guadalupe River in 1876.

In 1817, James Alfred McFaddin was one of the first Anglo-American settlers to arrive in the wild uninhabited province of Texas. McFaddin found conditions so inhospitable that he beat a hasty retreat back to the relative comforts of Louisiana.

In 1823, he returned in earnest and headed for Beaumont. Committed to the idea of a republic yet unformed, James joined the Texas force and fought in the Texas Revolution. For his participation, he was rewarded with land.

James was not the only McFaddin man to fight in the Texas Revolution. His son William, raised during the gestation period of the republic, joined the revolution at age 16 and fought under the command of Captain Andrew Briscoe. William fought in the Siege of Bexar and the Battle of San Jacinto, after which he accompanied Rusk to Goliad to help bury the charred remains of Fannin's army. It was there that William's military career ended. His shoes gave out. William McFaddin walked barefoot back to Beaumont and started a life of his own.

William's son, James, named for his grandfather and endowed with the same spirit, left Beaumont for Refugio County, where he spent 15 years as a merchant, banker, and trader. He kept the town's money in a safe in his store, and at the same time, he saved a little money of his own in order to buy a ranch. At the time, ranchlands around Refugio were limited. Most of the land had already been bought by the Welders, O'Connors, and Woods.

Consequently, James went farther south and began buying land and putting together the McFaddin Ranch. Confident as a rancher, James earned his spurs by "going up the trail"—the Chisholm Trail—a rite of passage second only to serving as a Texas Ranger.

The feel of cowboy life on the sprawling McFaddin Ranch was evident. So was the splendor of a former "cattle king." On his horse in the dusty corral on the ranch, chomping on his shortened cigar, Kerry McCan thought himself every bit the rancher his great-grandfather had been. The sultry coastal heat didn't seem to bother him a bit. If anything, he seemed exhilarated every time he roped a calf.

After two hours of steamy heat and bawling cattle, we drove to the McFaddin Mercantile Store on the self-contained ranch for a Coke. Before the advent of the highway, the store was a center for sustaining gossip and groceries in the rural community. Kerry's office, near the front of the store, overlooked a parking lot that had never met the twentieth century.

Kerry mentioned that six miles east of the McFaddin Mercantile there is a place on the ranch called Kemper's Bluff. In 1845, Captain John Frederick Kemper ran a trading post on the west bank of the Guadalupe River. Kemper prospered as a flood of colonists brought new trade and commerce to the republic that would soon become a state.

Kemper's Bluff was a strategic location, linking Indianola to San Antonio not only by ferry, but by wagon road—one of the few that existed in the country at the time. It was also the termination point for the smaller steamboats that were able to navigate the Guadalupe. Warehouse development was so rapid that the size of Kemper's Bluff threatened the more established nearby Victoria.

Unfortunately, according to Kerry, Kemper did not live to see the area prosper. A group of renegade Karankawas raided Kemper's little trading post on the banks of the Guadalupe. Kemper,

thinking they were the less volatile local "Kronks," ran out and shook his fist at the group of renegades. When Kemper attempted to fire his gun, a volley of arrows flew, and one struck him. His mother-in-law helped him back inside the cabin, where she and his wife, Eliza, broke off the feathered shaft and removed the arrow from the bloody wound. Kemper died in minutes while the Indians set fire to dry moss and shoved it under the door of the cabin. The women quickly doused the fire with a pail of water. At dark, the women escaped and headed to the Bass farm on Coleto Creek. There, Bass formed a posse. When Eliza returned to the outpost, her dead husband had been branded across his chest.

We drove by the blacksmith shop and to the church that was built in 1922 by Czechoslovakians who worked on the ranch. The dedication of the "Holy Infant Jesus of Prague" came during a drought so severe that ranchhands had begun stripping moss from the trees to provide feed for the starving cattle.

The school on the McFaddin Ranch is one of the last remaining schools on a family ranch in Texas. Kerry strongly believes that if you close the school, you close the community.

"Bussing fourth-graders 50 miles a day isn't good for them," Kerry said. "Our teacher/pupil ratio is the lowest in the state. We spend a good bit of money and we think we do a good job."

For Kerry McCan, heading up a large ranch that has been handed down through several generations to 40 or more heirs requires determination and diplomacy. Those who know him can attest at least to his determination. The job is not unlike being the board chairman of a publicly held company, the 40 heirs being an unwieldy board.

"I try to keep everyone happy and at the same time maintain my freedom of action," Kerry said. "It's almost impossible to contact 40 people for every decision, so it is really important that they trust whoever is running the business. My Uncle Al [McFaddin] told me, 'Make sure they have plenty of money and tell them nothing.' I don't agree with that. I've tried to be more open. We're doing a lot more today than running a ranch."

I asked Kerry if it was difficult for a son to work for his father, as he and many other ranchers have done. He was slow to answer, but finally said, "Yes...very." In 1966, he resigned his position with the ranch because of a disagreement. But when several people in management positions with the ranch got old and sick, and the ranching operation turned fragile, Kerry swallowed his pride and returned.

When Kerry is not juggling meetings at his office in Victoria or traveling 40 miles daily to and from the ranch, the Yale graduate spends evenings at his home near downtown Victoria, reading in the library he designed. Surrounded by streamlined bookshelves, milled from black pecan wood grown on the ranch,

Kerry plows through histories such as *The Trans-Mississippi West*, his current favorite. In his oversized, down-filled chair he sips vintage port and puffs on his cigar. He is distinguished by a tendency to let an occasional ash dribble on the Oriental rug where his labradors, Salty and Ketchum, nap.

Behind his home in Victoria, a Greek Revival museum called "The Nave" houses a collection of paintings that once belonged to Kerry's grandmother, Emma Di. Kerry's grandfather, James Ferdinand McCan, painted the classic American eagle that hangs in the lobby of the St. Anthony Hotel in San Antonio.

The recalcitrant Kerry denied taking his polo ponies with him to Yale. "They were too dumb to pass the entrance exam," he said. But in spite of his sometimes splintered sensitivity and his retrospective musings, the witty, erudite man enjoys a variety of world-class indulgences. Kerry's kaleidoscopic personality swings from snarly to sweet, and his views about women are announced on the bumper sticker on his car: "Susan B. Anthony is a two-bit piece." If you really scratch McCan's surface, you might find a "closet gentleman" and Renaissance man whose abrasiveness is a frequent cover for his excessive brightness.

Kerry's wife, Mary Carroll Groce McCan, has roots that, like his, tunnel back to the infancy of Texas. She is a descendant of Jared Groce, who owned 25,000 acres of land and had thousands of slaves. Groce owned the first cotton gin in the new nation of Texas, at Hemstead. His plantation, Liendo, was also there. (It was owned later by Texas sculptress Elizabeth Ney.) "Groce was among Texas's first 'big rich,'" said Kerry. "I don't know what my wife's exact relationship to Jared Groce was. All I know is that I never got my hands on any part of it."

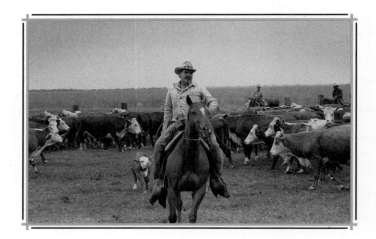

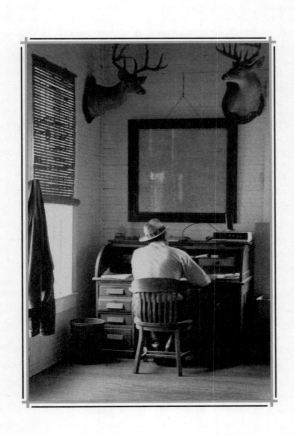

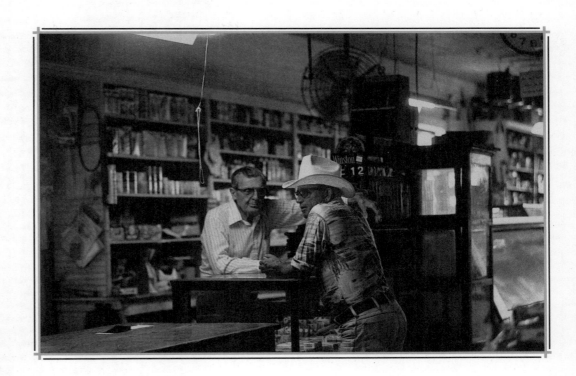

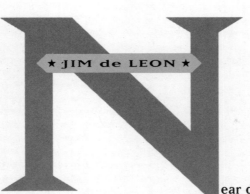

"It seems like you fight more for something that's inherited."

Jim de Leon
Victoria

Near downtown Victoria, narrow cooling towers cast dual shadows on a rosebush blooming effortlessly in Jim de Leon's yard. To the side of his house, aligning each other with somber authority, two granite tombstones guarded like monolithic sentinels. Jim's name was carved on one, his wife's on the other.

Jim de Leon, smiling and white-haired, opened the front screen door, grabbed my hand, and pumped it vigorously. His other hand held a half-eaten orange.

Inside the living room, a steady stream of western light fell on metal sculptures of wildlife. Near the center of the room was a large bronze relief of a man whose sharp features resembled those of a Spanish conquistador. The bronze relief, crafted by Jim, is of his great-great-grandfather, Don Martín de Leon, the founder of Victoria.

"Don Martín's image came to me in a dream," said Jim. "You know, he founded the colony of Guadalupe Victoria on the banks of the Guadalupe River and named it after his close friend, who was then president of Mexico. Guadalupe told him, 'Martín, if you wish to establish a town, I think you're the right man for the job. People need to inhabit the land, live on it, make it something other

than a wilderness.' At the time, Texas was void of settlers; only scattered tribes of Indians lived here.

"Martín was a great *empresario*, with so many cattle that the Indians nicknamed him 'Vaca Mucho' [Plenty beef]. He started off with over a million acres of land, on which he raised horses as well as cattle. A good supply of horses was essential for transportation.

"Because of his strong Catholic faith, Martín built St. Mary's church here in Victoria around 1824," said Jim. "His dream was to build a cathedral that would rival those in Mexico, but that dream was not to be. He was the first in his colony to be struck by cholera. He died in 1833, leaving behind him a reputation of which tall tales are made."

Some stories about Martín suggest that he was foolish for once trading a man 40 acres of land for a pair of boots. "At the time," explains Jim, "land was for the taking, and the closest bootmaker was well over 100 miles away, in San Antonio. In my opinion, Martín gave the man 40 acres because he probably needed a good pair of boots that offered him protection from thorny bushes and rattlesnakes."

Jim remembers that as a child, children at school teased him about his great-great-grandfather's escapades involving a servant and a cannon. C. L. Douglas, in *Cattle Kings of Texas*, tells it this way:

On a bright spring morning in 1806, Martín de Leon and a servant were going out on a journey to round up Don Martín's best beeves, driven away by "devil" Comanches. He sent his vaquero for the small portable cannon. Old but serviceable, it would scare the Indians. The cannon was hoisted onto the mule's back and cinched on. Its iron muzzle pointed over the animal's hindquarters. Less than ten miles from the ranch, Martín and the vaquero came upon a Comanche scouting party. The surprised vaquero forgot to remove the cannon from the mule's back before lighting the fuse. The Indians fled. The mule did not recover.

After the death of Martín de Leon, his son, Don Fernando, carried on the major affairs of the colony. His ranch, the Escondida, was located on the banks of the Guadalupe River, seven miles north of present-day Victoria. Had it not been for unpredictable twists of fortune and the war for Texas independence, the de Leons might have weathered the turmoil and salvaged their vast holdings, but Don Fernando found himself trapped between determined opponents.

In 1836, Don Fernando purchased $35,000 worth of goods in New Orleans and shipped them aboard the *Anna Elizabeth* steamship to Linnville, above Lavaca Bay. The cargo of the *Anna Elizabeth* was contraband of war—materials and ammunition for Texas volunteers and the colonists at Guadalupe Victoria. When the

schooner was attacked and partially sunk by a Mexican cutter, Don Fernando was captured and thrown in jail in Brazos de Santiago. (Brazos de Santiago was a port located between Padre Island and Brazos Island, east of the southwest corner of Cameron County and not far from present-day Port Isabel.)

He eventually escaped and returned to Victoria and his Mexican colony, but he was arrested again when General Don Jose Urrea came to Victoria and accused him of hiding contraband in a ravine at Dimmit's Landing on Lavaca Bay.

After his second arrest, Don Fernando promised that if he were released, he and his brother would expatriate themselves and leave with the returning army to Mexico. His promises brought him no luck. Almost immediately after his release, he was arrested again on trumped-up charges—this time by the Texas army.

He was finally released, without trial, and with his family left the port of Linnville for New Orleans. (Linnville was located three-and-a-half miles northeast of Port Lavaca on Lavaca Bay. It was destroyed by a Comanche raid on August 8, 1840, and never rebuilt.) This one-time patron of the Texas cause and one of its richest men fled for his life, taking with him only the clothes on his back, leaving behind his home, land, and the patriarchal herds that were later captured by invading Anglo-Americans.

Perhaps in times of war there is no justice. Certainly Don Fernando found little. The lands of Victoria's once-powerful *empresario* and his family dwindled to a remaining seven acres, and now Jim has those up for sale.

Jim de Leon is a dignified man who enjoys the legacy left him by his great-great-grandfather. With his own hands he made the elaborate wrought-iron fence that surrounds Martín de Leon's gravesite in Victoria. Because of antiquated measuring systems and hard-dealing Texans, many oil-rich ranchers presently live on lands that were once under Martín de Leon's domain. Without a trace of bitterness, Jim says philosophically, "Suppose some Good Samaritan says to me, 'Jim, I'll give you 10,000 acres of land if you'll pay the taxes on it.' I'd be run crazy, because I don't have the money to pay them. Now I have something to worry about, right?" Jim smiled. "What I have, at this point in my life, is much less, but well, I don't have to worry very much about it, either."

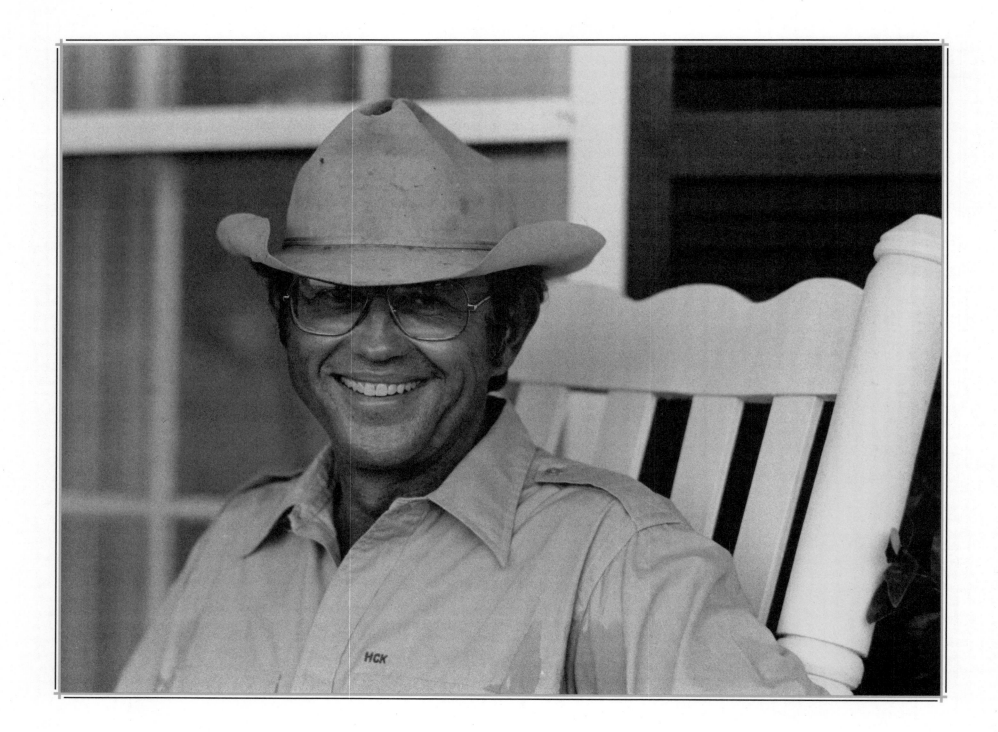

★ HENRY CLAY KOONTZ ★

"The Newport dowager looked through her monocle at the sandy-haired young man seated at her left. 'And tell me, young man, where are you from?' 'I'm from the bo-vine aristocracy of Texas,' he replied."

Betty Brooke Blake

Henry Clay Koontz
(1934–1985)
H.K. Ranch
Near Placedo

Before I met Henry Clay Koontz, he was described by a friend as slightly flamboyant, disarmingly witty, and universally and justifiably well-liked.

My friend's description of this seemingly unflawed man, whose looks she described as handsomely "patrician," was accurate. She failed to mention only one thing: the way he talked.

Outside Placedo, not far from the town of Victoria, a long road stretches across the coastal plain and ends at a house that was converted from an old church. The house sits on the flat landscape like a facade from a movie set. Between two white columns, a Texas flag waves in the afternoon breeze. I got my first glimpse of Henry Clay Koontz as he sat under that flag, in a pristine white rocking chair. A plaque near the front door read: "On this site in 1836, absolutely nothing happened."

"Y'all come in outta that ol' hot car," said the boyishly handsome Henry Clay. "Come sit on the porch and we'll have our interview here."

"This porch was built to see the cows," he said. "You know, when I was growing up, there were no roads coming into the

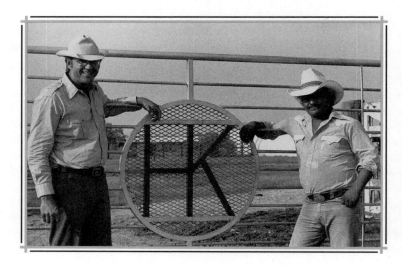

ranch. It was very hard to get here, so Mama hired a tutor for my sister Emily and me. The turnover rate was alarming. I never read anything because I wore glasses. Mama thought I should save my eyes to look at the cows.

"Gertrude Emily, my sister, said it wasn't fair that she had to read and I didn't. So Emily and I would float in the swimming pool while the tutors would read us English history. As soon as Emily and I would get rid of one, Mama would hire another. Sometimes she would give them a bonus so we could finish the damn course."

Henry Clay discussed the family's arrival in Texas and his great-grandfather, Captain John N. Keeran, who moved to Texas from Virginia via California, where he raised wheat and sold horses to Brigham Young. He was a successful man.

In a venture with other businessmen, he bought some railroad-owned land in Texas. Someone had to check it out, so Keeran got the short end of the stick and headed for Texas. It wasn't easy. He took a boat around Cape Horn to New York, a train to St. Louis, a riverboat down the Mississippi to New Orleans, and another boat across the gulf to Indianola. At the time, Indianola was the largest port in Texas.

"Great-grandfather liked the ranch," Henry Clay explained, "so he sent for Great-grandmother Claud, and Great-aunt Bertie. That was one hundred and thirteen years ago.

"From the beginning, this ranch was a cattle ranch.

Great-grandfather bought out the other partners and bid with legendary cattleman Shanghai Pierce for the first Brahma cattle to come to Texas in 1878. The cattle came into Indianola by boat. Now we jet them all over the world."

The afternoon breeze subsided and the muggy stillness put an end to our conversation on the front porch. Sweat mapped Henry's khaki shirt. He had just come in from working cattle.

Inside, handsome, massive furniture "that belonged to Mama" commanded the living room. On one wall hung a sequined ball-gown with a train. Henry's daughter had worn the dress several years ago for her debut as a duchess in San Antonio's Fiesta celebration. As we left the living room on our way to the den, Henry Clay cast a glance at the hanging dress and murmured, "What else can you do with the damn things?"

We sat in the den, which was filled with awards given for prize Brahma cattle. "We call this the negotiation room," Henry said. "When Latins come to the ranch, they love to haggle over the price of cattle, so we put them in this room where they can see all our blue ribbons. If we come to an impasse I'll say, 'I don't care whether you buy the cattle or not. I'm not coming down one penny.' Mary Sue, my wife, comes in, sits at the piano, and plays 'El Rancho Grande.' She says, 'You all need these cattle, so don't be so chintzy,' and they all laugh, and the negotiations reopen."

Henry grabbed a magazine. Mary Sue was on the cover.

"She's a doctor's daughter, and the lady doesn't cook, you know. We either have a cook or we don't eat too well. People come down to the ranch for an interview wanting our favorite recipe, and we have to steal some from a neighbor's cookbook. She's got a marvelous personality, but she can't boil water!"

Bird hunts on the H.K. Ranch were such grand events that television host Hughes Rudd came down to the ranch from New York to televise the happening. People hunt for a while, then stop for lunch in the middle of a pasture. After two hours of quail and champagne, they load the guests on what is called the "flotilla." "That's a big flat gooseneck trailer that we cover with old Oriental rugs, then we load up the mariachi band and all the guests and we sort of ride down the road and follow the dove or quail. We have a gr-r-r-rand ti-i-i-ime," Henry Clay said.

Hughes Rudd should have stuck around. If he had, he would have discovered that the lives of Henry Clay Koontz and his predecessors are the stuff of movies. Take the Sutton-Taylor feud, Texas's longest and bloodiest feud. It grew out of the hard times after the Civil War. Over a period of a year more than 200 people were killed—some because they refused to take sides.

Henry discussed his family's involvement: "Life was so dull back then, people got tired of being on horseback all day and watching the blasted cattle, so they loved to keep a feud going. It was their only source of excitement.

"One night, oh, I forget which group, came to the house to see whether Great-grandfather was going to join them or the other, or they were going to kill him. But he happened to have the yellow fever or something, so they left, saying they wouldn't shoot a sick man.

"My Great-grandmother Keeran held either a Sutton or a Taylor in her arms while he died and wouldn't let them shoot him because he was dying. But I think that was as close as our family came to being involved in that particular feud. We've got enough of our own."

Now, somewhere in this world or perhaps another is Henry's long-overlooked elocution teacher, and not mentioning Henry's dialect would be like forgetting to close the gate. It was contagiously Southern, clipped English orator, with a trace of guacamole thrown in. Perhaps a bronze plaque should be erected for the onslaught of tutors who had a hand in creating whatever on earth it was that Henry spoke. Anyone who ever heard him can't forget his audible landscape of convoluted lingo. Whenever his name is mentioned, people automatically open their mouths and say, "Ho-o-o-ow ar-r-r-re yo-o-o-ou?"

Henry Clay Koontz was killed by a drunken driver on July 19, 1985.

Goodnight, Henry. All of us miss you!

"Stories of my great-grandmother, Mary Josephine Durst, always captured my interest. She lived on the frontier when Mexican bandits raided frequently. When her children became school age, she and Major Armstrong moved to Austin. They lived in a large, two-story house. He was putting the children to bed one night, and there was a rustling on the trellis outside the window. There were no telephones in those days, and the Major was out of town, so there was no use in her screaming. She did not allow herself the luxury of fainting, so she walked over to the fireplace and picked up a poker. When two hands came up over the windowsill, she came down with the poker. There was a dull thud outside in the yard. No more was heard of the intruder."

General John Bennett
Garcitas Ranch
Near La Salle

locks of blackbirds stalled and dove in harmony over large green fields divided by a flat, black highway into La Salle.

I reached General John and Eleanor Bennett's ranch, out of La Salle, ahead of schedule. They were to arrive shortly from San Antonio. Dampness and a low, gray fog clung to the bottom lands that surrounded the hilltop ranch. The place seemed quiet, remote, and disconnected from humanity's extremes.

A distance away, a tiny creek continued its flow toward the Lavaca River, five miles downstream. Across the creek, flat pasture land rose to a deserted plateau. The rise, vacant and helpless from defeat, was the alleged location of La Salle's Fort St. Louis.

Cattle grazed near the hill where, in 1685, La Salle raised the fleur-de-lis over his newly built settlement. He surrounded the six buildings with a wooden stockade that offered protection from the cannibalistic Karankawas. Choices were limited: protection or starvation. Those who ventured out on food expeditions often ended up being a picnic for Indians, who frequently cut hunks of meat from the Frenchmen's bodies.

The unfortunate colonists left at the fort after La Salle's

men betrayed and killed him were massacred by the Indians. Later the Spanish arrived and burned the remnants of the fort. No trace of it exists today.

When the Bennetts arrived from their home in San Antonio and unloaded their car, John built a fire in the adobe fireplace of the comfortable ranch house. Eleanor reminded her husband not to bump his head on the walrus tusks that hung over the fireplace—a kill by their son in Alaska.

The mesquite fire blazed away the gloom of the day's dampness. The room in which General Bennett and I sat had a look of comfort and of decades of a family being a family.

The General talked about the pioneer stock from which he came—a labyrinth of ancestors with sledgehammer grit. The first John Bennett, the General's grandfather, came as a child from Alabama in a wagon train in 1837, the year after Texas gained its independence from Mexico. He settled in the Cuero area. The General's maternal grandfather, Major John Armstrong, was born in Tennessee and as a young man came down the Mississippi River on a raft. He stopped in New Orleans, where he boarded a boat from Galveston and came to Texas. He joined the Texas Rangers and became famous for capturing desperado John Wesley Hardin. [For details, see the chapter on the Armstrong Ranch.] In 1878 he married Molly Durst, whose father, James, a Texas patriot and Indian trader at one time, lived in the Old Stone Fort in Nacogdoches.

The General's paternal grandfather got his start driving cattle up the Chisholm Trail. John Brackenridge was so taken with the trail boss that he advanced John Bennett $25,000 to move his herd up. Bennett paid back the loan and invested his profit in the Garcitas Ranch.

"In those days, the ranch was called the Bennett and West Ranch. West sold out, so Grandfather owned two parts of the Bennett and West partnership," John explained.

"The two sons, my father and young Ike West, didn't have too much in common, so they divided up the ranch. Father came up with the plans to divide the ranch into three parts, and he gave Mr. West the first choice. Father would be satisfied with any two parts he got. There's an interesting side to this story. In those days, oil had not been discovered down here. Minerals and surface sold together. Mr. West was interested in the carrying capacity of the range. He didn't consider bayfront or riverfront, or anything recreational. The arrangement was strictly business. Mr. West chose the southwest corner of the ranch. Later, Mobil Oil's largest domestic oil field came in on the West's side, not on the Bennetts'. My wife, Eleanor, drove down to look the area over and said, 'I've never seen a geological formation divided by a barbed-wire fence.'"

Eleanor Bennett also came from a pioneer family. Her father, Benjamin Quinn Ward, owned the Crescent V Ranch near

Blessing, Texas. At one time, he was the legendary Shanghai Pierce's partner.

General John Bennett is a wry-witted, self-effacing man whose dignity prefers to downplay his heroic role in World War II. He was awarded both the Bronze and Silver stars.

In 1939, he joined the National Guard. The easy, soft-spoken son of Jamie Armstrong Bennett was concerned about events taking place in Europe. His uncle, Charlie Armstrong, told him to return from the conflict with a rank no lower than major. Three years later, Major Bennett stepped off a military transport plane in England. There he requested active combat duty. He became commanding officer of the 349th Bombardment Squadron and their B-17 "Flying Fortresses."

His first mission would have a profound effect on the outcome of the war. The Germans were developing an atom bomb at a strategic and hard-to-reach location in Norway called Vermork-Rjuken. The plant hung on the side of a cliff, deep within a gorge. Steep mountain walls rose from each side, making the gorge impossible to attack.

Military leaders decided to risk an air attack on the factory after Albert Einstein warned President Roosevelt that "heavy water" was the key to the German atomic bomb. Both men knew that completion of the bomb would mean total devastation for Western Europe.

Predawn on November 16, 1943, three divisions of the 8th Airborne set out for Norway. Two divisions were assigned diversionary targets. Major John Bennett, commander of the third division, was assigned Vermork-Rjuken.

Arriving 18 minutes ahead of schedule, Major Bennett, reluctant to strike before the workers left for lunch, made a soul-searching decision. He ordered the entire formation to turn back and circle for 18 minutes in order to spare civilian lives.

When the Flying Fortresses approached again, they were met by intense antiaircraft fire. One bomber was set afire, and another with a faulty engine started home. Ten men parachuted from flaming planes into the sea. Bennett, in the command plane, led the way over a network of mountains and forest and headed straight toward his target.

In the next 33 minutes more than seven hundred 500-pound bombs fell into the hidden valley where Norsk-Hydro made its "heavy water." After the war, German scientist Dr. Kurt Kiebner said that it was the elimination of German heavy-water production in Norway that led to Germany's atomic failure. Years later, the movie *Twelve O'Clock High* was patterned after this mission, with Gregory Peck playing Bennett.

On his next mission, he assumed command of both wings after his commander had been downed following a vicious attack by enemy fighters. He successfully maneuvered the bombers over a

high-priority industrial installation and fired away. This gallant mission earned him the Silver Star.

General Bennett, whose dressing habits lend themselves to the English countryside as well as to the Texas range, drove me down to the point on their ranch where the land runs into Lavaca Bay. There, across the slate-gray water in a sky beginning to mist, the serenity of the landscape was interrupted by a strange, out-of-place building in unspeakable aluminum. "What," I asked, "is that?"

"One of the evils of civilization," he replied.

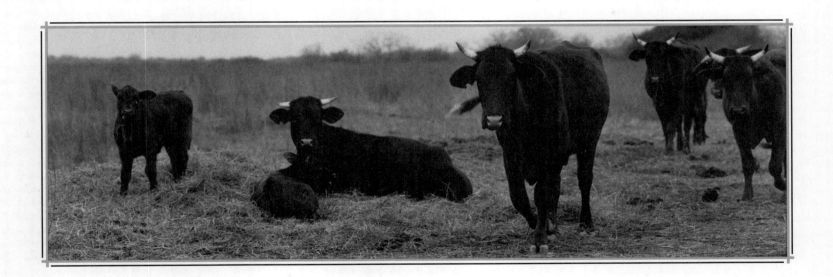

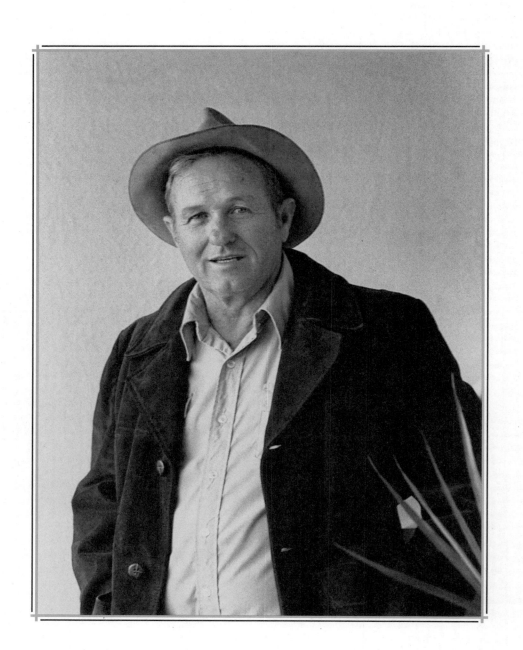

"I loved ranching as a kid, and after 25 years, I still love it."

Lon Cartwright
Twin Oaks Ranch
Near Dinero

ilvery moss cascaded down from the branches of ancient live oak trees along the banks of the Nueces River. Finger roots, stretching out like extensions of time, were stripped bare by the wake of the ferry that crossed there 150 years ago.

The point, on the main route between Texas and Mexico, was originally called Barlow's Crossing. As the story goes, in 1836 Santa Anna's men were riding north, carrying the money to pay the troops fighting at the Alamo. Shortly before they boarded their horses on the river ferry, they were fired on by seedy bandits. Santa Anna's troops returned the fire, and the bandits fled in a swath of dust back to the safety of "no man's land." The only fatality was a bulging money bag that poured forth a stream of gold coins. From that day on, Barlow's Crossing was called Dinero (Money).

In 1940 there were two businesses and a population of 50 in Dinero. In 1985 things hadn't changed much. Not even a Dairy Queen graces Dinero's dusty streets.

The day was overcast. Mist hung low as it does on bucolic mornings in the Scottish countryside. At Twin Oaks Ranch outside Dinero a fire crackled in the living room's large fireplace. Leigh and

Lon Cartwright sat on an overstuffed sofa in front of the fire. If one were to rate Lon Cartwright's personality for likability, it would easily earn five stars. A vibrant "get-along joy" inhabits his face, which visibly lights up every time he speaks.

Lon motioned to an ancestral portrait over the fireplace. "That's my Uncle Holman. This place used to belong to him. He and my Aunt Claire didn't have any children of their own, so every summer all my cousins came down and helped them work on the ranch. Some of them would get a bad case of sunburn and some would blister their hands, and none of them wanted to ranch. Now don't get me wrong, some of my cousins are tops in their fields. They're lawyers, geologists, and judges, but none of them wanted to ranch. Uncle Holman invited me and Leigh down for a week 25 years ago, and we're still here."

The entrenched Cartwright family has resided on Spanish, Mexican, and Texas soil since 1819—two years before Stephen F. Austin planted his first colony along the banks of the Brazos, and 17 years before Texas gained its independence.

John Cartwright, Lon's great-great-grandfather and the founder of the Cartwright legacy, left North Carolina for one reason: land. Spain offered 4,428 acres to those who would settle the area and conquer the Indians. It was a discretionary opportunity offered to Americans so that the Spaniards could rid the land of its inhabitants and then occupy lands peacefully and without risk of attack.

John settled six miles east of San Augustine, in the Spanish province of Texas, and called his homestead Apologotcho. It was one of the earliest prominent American settlements in the Spanish republic. John and his son, Matthew, built a mercantile store and sold tools to settlers who were building a new life in a hostile territory. Both John and Matthew served as colonizing agents, handling paperwork and surveys for those Tennesseans and Kentuckians who could not read or write. Their fee for the service was a small percentage of the acreage.

Matthew later supplied soldiers fighting at the Alamo with blankets and food while it was still possible to deliver them. Travis sent Matthew a final message from the Alamo in battle-worn script when he recognized the futility of his course.

After the revolution Matthew sold mules, horses, and provisions to the folks from Tennessee and Kentucky before they returned home. Most traded their land script for provisions—often 1,280 acres of land for $600 worth of goods. The script varied large to small according to the number of battles the soldiers had fought.

Early abstracts show that in order to prove ownership of land, one had to seek out his claim, pile up a bunch of rocks, throw dirt into the air, bellow like a mule, and then bellow like a bull. Matthew must have at times suffered from severe hoarseness. From the land script he traded for provisions, he bellowed up more than a million unconnected acres.

"Yeah," Lon said, "Matthew got out to West Texas and he'd gotten so big he couldn't get back on his horse. He had to walk five miles back to town. That's why Leigh is after me to reduce all the time."

The ranch was a wedding present to Lon's Uncle Holman and Aunt Claire from Claire's father, Cyrus Lucas.

"When Holman and Aunt Claire moved here in 1915, my uncle bought his first car," Lon said. "Up to that time he had only driven buggies. Well, he loved to drive, but he would forget how to stop. Every time he would get to a gate—and there were 23 between Dinero and Beeville—he would drive around in a circle while Aunt Claire would jump out and open the gate. Then when she closed the gate, he'd make another circle and she'd jump back in. They came to this one gate and Claire vaulted out of the car and broke her leg. Uncle Holman, afraid to stop the Model T, drove through all the gates back to Beeville to get her to a doctor."

The ranch, 50 miles from the coast, has been visited by several big-winded ladies. Hurricane Carla moved 28 of the ranch help into the main house to wait out the storm. The house, with its 18-inch walls, held against Carla's winds; the roof, electricity, and 28 windmills did not.

During Hurricane Beulah, rising water cut off Lon from his cowboys. His cattle were in an area of bottom land and would drown unless he could get them out. He saddled two horses, one for himself and one for his daughter, Claire, who was 8 years old. Together they rode through a pelting rain, rounded up the cattle, and swam them out of the low area.

"When the kids marry," Lon said, "I want it to be just like the television show *Dallas*. I mean, you know, come down every morning, have a pretty wife and kids, and have them all live right here at Twin Oaks."

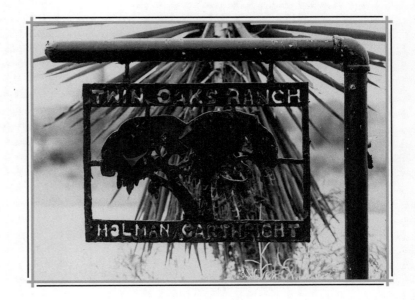

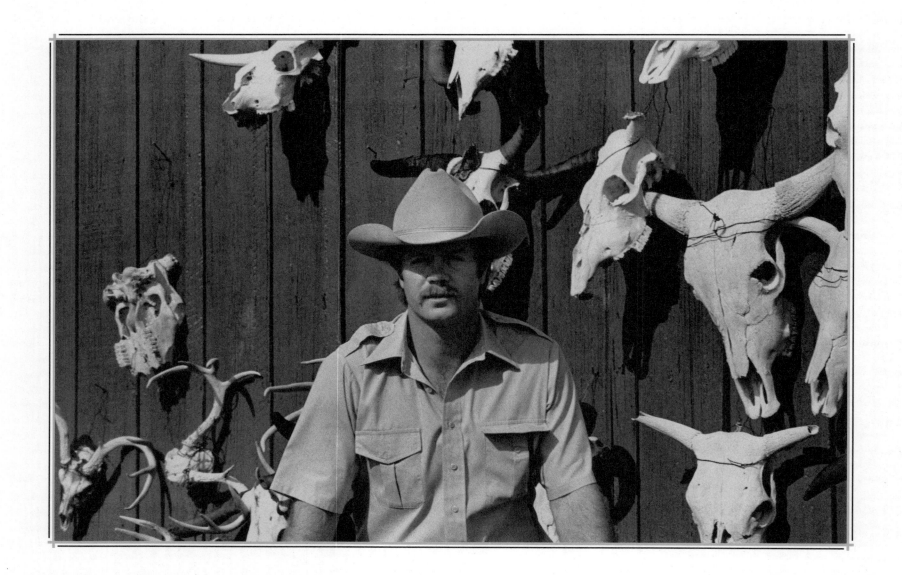

"It's hard to live off the cattle business unless you have some other type of income—say, oil and gas—that comes from the land."

David Killam
Pescadita Ranch
Surrounding Laredo

He was a tall, easygoing, well-connected man, accomplished in business acumen and adroit in handling business situations. His actions were firm and articulated with finesse. "That really wasn't our plan for the best usage for that property, but we'll consider your proposal," said David when a phone call interrupted our conversation.

Outside his office window, sage and cactus tangled in undeveloped land owned by the Killam family, all of which land-locked the city of Laredo, forcing the Killams to consider development rather than ranching, their preferred interest.

"The cattle business, that's what we love to do, but...." The telephone rang again.

Born to a family of visionary expansionists, David Killam is heir to the legacy of a wildcatting boomtown that began 40 miles away, Mirando City. Mirando is derived from the Latin word *mirar*, meaning "to wonder at" or "marvelous." Mirando City is at the center of a geological area that harbors one of South Texas's greatest oil fields. David's grandfather, the late Oliver William Killam (known as "King Petro") discovered the place in 1920 after seeing the structural

formation of Mirando Valley. He was convinced that this was the place to drill. Stories of his early discovery, told by folks still living in the sparse area, say that Killam used a divining rod to lead him to oil. Others say he would fly over a possible site in a small one-engine plane and drop a sack of salt on the place where he would drill. Later, he would secure a lease, purchase a rig, and hoist a wooden derrick.

His first well was a dry hole. He lost the second one to bad casing. He then called on Otto Middlebrook of Hebbronville to drill Mirando Oil Company 3 Hinnant. On April 17, 1921, they struck oil. It was the first commercial oil well in South Texas. Ranchers who had suffered from a recent drought benefited from the Killams' efforts. Killam leased the land for production and the boom was on.

In 1921, Killam founded Mirando City in order to have a nearby center for his fast-growing oil business. Lack of water in Mirando didn't hamper its growth; Killam had it hauled in on the Tex-Mex Railroad in tank cars. The cars served as the water-works and the town pump. Among the many people who had "come to follow the boom," more than one fight was fought over who would get to bathe first in the water hauled in from Laredo. As far as the roughnecks were concerned, water was far more precious than oil.

Ranching came later for the Killam family. Their ranch,

the Pescadita (Little fish), was acquired from the Ortiz family after World War II.

"The ranch had been a grant from the King of Spain," said David, adding that the Ortizs had owned a large tract of land around Laredo, and this ranch was part of it. "Because our land does surround Laredo, there are a few small tracts we are going to develop. But again," David emphasized, "we're not in the development business. We're doing it out of force, more or less. In the future, we're going to try to stick to cattle business and the life-style that goes with it."

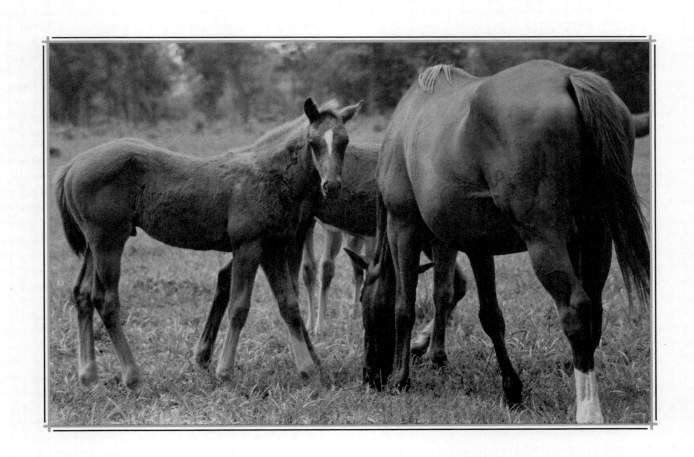

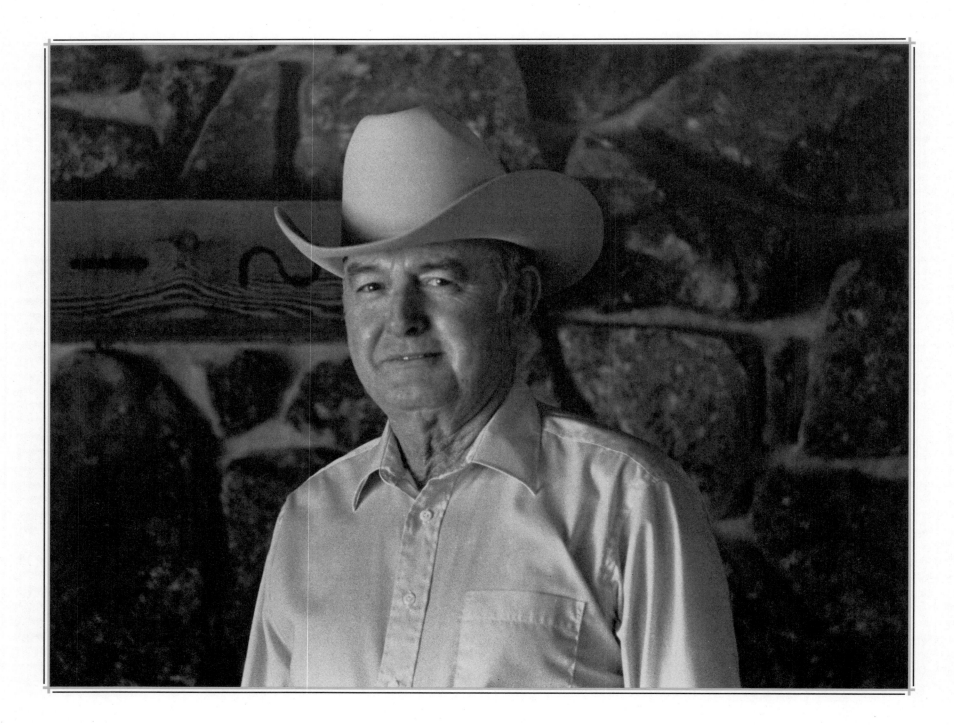

★ ALBERT GATES ★

"They say if you drink the water from the Rio Grande, you'll always return for more."

Albert Gates
Gates Ranch
Near Catarina

It's a well-known but seldom-discussed fact: If your family hasn't lived in South Texas for at least 50 years, you're considered "fairly new to town" and boundariless to boot.

No one confirmed this fable as well as frontiersman-rancher Albert Gates. On my third phone call I accidentally mentioned Holmes Dinn. I could hear the light click on in Albert's head. "Holmes," he said, "I guess anyone who calls him Holmes is OK; newcomers call him Jim." The boundaries were traversed, and I—the newcomer whose shallow roots barely scanned 40 years—set out for the Gates Ranch not far from the town of Catarina.

On the approach into Catarina, I immediately sensed the former grandness about the place. Palm trees lined both sides of the highway and merged into two large brick pillars topped with Roman urns. Under one of the urns, a graffiti artist had scribbled, "Bye, bye, sucker!"—a prophetic statement if there ever was one.

Ahead, a mesa rose out of the blue-skied wilderness that 2,500 people once called home. A small grocery store, a closed hotel, and a service station were all that was left of a fairy-tale promotion that in the '20s had temporarily turned droughty pasture

lands into a flowering oasis. It was a brilliant scheme, but as Dolph Briscoe, Sr. once prophesied, "This is brush country, and that's all it ever will be."

Catarina was at one time part of the Coleman-Fulton Pasture Company. It was sold to Charles P. Taft, brother to U.S. President William Howard Taft, and David Sinton, both livestock financiers from Cincinnati, Ohio. Sinton's daughter, Ann, married her father's partner. Ann and Charles accumulated some 250,000 acres and called their massive land-holdings the Taft-Catarina Ranch. In the '20s, the Taft-Catarina was sold for $5.25 an acre, and later was sold again to a syndicate from Kansas. There began a grand scheme. The promotion of Catarina Farms was an unrivaled extravagance.

Out of the scenic shrub the developers built streets, put in electricity, and created a well-lighted highway leading into town from Laredo. The ambitious group added a waterworks, a telephone exchange, and a 14-acre park with a swimming pool. They planted palm trees and built brick columns, fancy gateways, and, of course, a hotel for all who would come to revel in the concept.

Things in Catarina were popping, but the real coup came when the group hired Charles Ladd as a colonizing agent. This boy was a master showman who dressed in ten-gallon hats, jodhpurs, and knee-high riding boots. Ladd dazzled the prospective customers. Real-estate agents in the north rounded up "guests," who arrived by train to inspect real-estate projects in Corpus Christi, San Antonio, the Valley, Laredo, and Catarina Farms. Ladd met the trains personally. He escorted the excursionists on a tour of his own showplace home, which was exotically landscaped with citrus trees loaded with fruit. No one suspected that Ladd had just shipped in the trees, fully grown, from California. Visitors from the North loved it. In 1928, while the rest of the country was suffering severe economic decline, Catarina was booming.

Eventually, lack of rain caused small farms around Catarina to fail. Discouraged Northerners headed home, and Catarina Farms, as Briscoe predicted, returned to brush country. Alonzo Gates and Dolph Briscoe, Sr., among others, began buying it up.

Albert Gates met me at the entrance to his ranch outside the sleepy town of Catarina. Mrs. Gates had the noon meal on the table when we arrived at the house. After lunch, we had coffee in the large two-story den. Navajo rugs hung at random from the tall ceilings in the sparse room. The Gates are knowledgeable rug collectors.

Albert's father, Alonzo, was born in Pearsall and raised in Loma Vista. He got his start in Webb County close to a small settlement named Cactus, between Encinal and the Callahan Switch. From there he went to eastern Webb County, 25 miles north of Bruni, and ranched until he traded for some of the acreage near the area where his son ranches today.

"In the '20s my father bought this ranch that had first belonged to the Taft family, then to the Catarina Farm Company," Albert said. "The people who promoted the Catarina Farm Company brought down home-seekers from Wisconsin, Minnesota, and Illinois by train to the Valley. They'd point out fields of orange groves and offer get-rich promises, stop off at the Cadillac Bar in Nuevo Laredo, serve them a few drinks, and bring them to Catarina. The place looked like an oasis. The going price was $50 an acre.

"After the Depression hit and crops had failed, people headed home. My father began tracing down the owners in order to buy the land from them. By that time they had scattered; some had died. Their heirs had never heard of Catarina."

Albert told the story of the early Spanish explorer Antonio de Espejo, who traveled over trails located near the ranch on his way to New Mexico."It's often referred to as the Trail of Mirrors," said Albert.

Four hundred years later, a new kind of explorer cut a swath through the sky high over the Gates Ranch. "Neil Armstrong led the team of astronauts in a visual-acuity test," Albert explained. "NASA contacted me to use our ranch so that they could determine just what the astronauts could see on the ground from space. They cleaned off 12 ninety-acre blocks in checkerboard fashion. In the center of each of these 12 blocks they placed 12 or 15 pieces of plywood and styrofoamed one side to reflect light. Each block had a different configuration. At each pass they would look down and read the pattern, then the ground crew would change the configuration. Ninety minutes later they would fly over again and NASA would ask if they could read the change. From 110 miles in space the answer was affirmative."

Next to a portrait signed by the astronauts was a photograph of an early Texas oil field. "My father was a partner with O. W. Killam, the man who brought in the Mirando field. Mirando was a boom town with lots of activity. They used big teams of horses to build slush pits. Blacks drove the teams. All this activity was foreign to South Texas at the time," said Albert.

"Roads around the Mirando City were really trails that twisted through the pastures. My father was driving his Model T with the top down. He rounded a curve and came front-to-front to another car with several people in it. He reached for the emergency with his left hand, and when he looked up he was nose-to-nose with this fellow standing in the seat of the other car with a .30-.30 leveled straight at him. They were *tequileros* from Mexico," said Albert. "My father held up both hands to show he didn't have a gun. If he'd had one, they would have probably killed him. These fellows played for keeps."

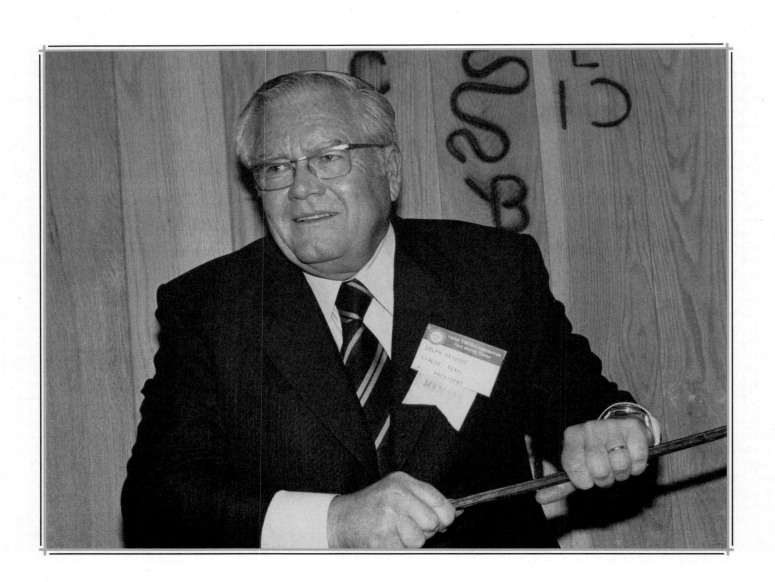

"Dolph Briscoe eradicated the screwworm.
People in the ranching business don't think anything about it
anymore. They have no idea of the hardships we went through. It
was single-handedly the biggest thing that's ever been done for the
cattle business. I don't think Dolph's ever really gotten the proper
appreciation he deserves."

Red Nunnley

Dolph Briscoe
Briscoe Ranch
Near Catarina

guide at the bank in Uvalde led a group of
Bermuda-shorts-clad tourists into Dolph Briscoe's reception room
and turned off the lightswitch. They oohed and aahed over the
special illuminating effects of a painting titled "Snowy Night." For
some reason, the painting looked better in a darkened room.

The guide pointed out the office's nineteenth-century
decor, which included a Wells Fargo desk and "Gone with the Wind"
lamps. In five minutes the tourists were gone. At the other end of
the room, overlooked by the tourists, was a large picture of an early
Briscoe relative, painted in 1776 by Gainsborough and found in
England by Dolph's wife, Janie.

Dolph, a former governor of Texas, appeared and led me
back to his Texas-sized office filled with Texana, right down to the
plastic bluebonnets that spilled out from the top of a pitcher that sat
inside a washbowl—the kind you see on *Gunsmoke*.

Red Nunnley, Dolph's partner in the cattle business,
had recommended to him that he see me. The 30-year friendship
between the two men was enviable; besides, Red felt that a number
of Texas publications over the years had maligned his friend.

I liked Dolph Briscoe the minute I met him. He was a decent, sensitive person who, in addition to being Uvalde's most respected citizen, was the largest individual landowner in Texas. This soft-spoken, unassuming man had pioneered chain-clearing techniques that turned the open brush country into extraordinary pastureland. He had razor-sharp business sense combined with a self-effacing likableness.

His office walls documented a well-spent life. Pictures of distinguished ancestors who shared the ripe glories of Texas beginnings were alongside Dolph, Janie, and their children. The room, like Dolph himself, was warm and personal. Dolph leaned, elbows forward, on his desk and told about the first Briscoe to come to Texas.

"Andrew Briscoe, a distant relative, obtained a land grant from the Mexican government on the Brazos River in Fort Bend County," he said. "Andrew came from Mississippi and registered as a citizen of Coahuila and Texas in 1833. He opened a general merchandising store in Anahuac in 1835. The Mexican government raised his taxes; he refused to pay, so they put him in jail. His jail-mate was a fellow named Harris. Later Andrew married Harris's sister, Mary Jane, known as 'The belle of Buffalo Bayou.'"

"Andrew would later join W. B. Travis and his volunteer army," Briscoe went on to explain, "to help drive Antonio Delorio Velasco out of office. Andrew was captain of the volunteer army that fought at the Battle of Concepcion, and he followed Ben Milam in the Siege of Bexar. Andrew Briscoe later attended the Convention of 1836 at Washington on the Brazos and signed the Texas Declaration of Independence. He served under Sam Houston at the Battle of San Jacinto, and later Sam Houston named him the first county judge of Harris County. He had a significant life," Dolph said.

Dolph Briscoe's father left Fort Bend County in 1911 and came to Uvalde. "He had gotten to know people in this area while attending Peacock Military Institute in San Antonio," Dolph said. "He traded horses. The market in Uvalde was good, so he and my mother settled here. Besides, he thought the county had great ranching potential.

"My father went to work for Ross Sterling, the founder of Humble Oil Company, who wanted to get into the cattle business. Later, he became Sterling's partner in a 10,000-head-of-cattle lease operation."

In 1930, when the Depression hit, Sterling lost his land. But Dolph's father had some lease land known as the old Catarina Ranch, and he moved there to start over again from scratch.

"He lost everything he had," Dolph recalled. "It was not until 1939 that he was in a financial position to start again. His first purchase, with the help of a federal land-bank loan, was 10,000 acres at the Catarina Ranch. That was the beginning of what we have today."

There's hardly a cattleman in Texas who doesn't bring up, from time to time, Dolph Briscoe's eradication of the screwworm. But he tells the story best.

"In the late '50s I went to Florida with Norman Moser, president of the Cattle Raisers Association, and Dale Welden. Florida had been successful in eradicating the screwworm, which was then the number-one problem facing the cattle industry. We wanted to develop a program here in Texas and other Southwestern states. Northern states were exempt because the cold weather would kill out screwworms. Our main infestation came from Mexico. Therefore, the U.S. Department of Agriculture took the position that the program wouldn't work here because of a continued danger of reinfestation from Mexico.

"When we arrived back in Texas, we set out to raise money. We held meetings in different counties with livestock producers to put in so much a head. We gambled against the USDA, who maintained the position that it couldn't be done. Maintaining that it could was an entomologist named Dr. Bushman, an employee of the USDA. Bushman believed the project would work. The USDA wanted to fire him—then Lyndon Johnson intervened. He was a good friend of mine, and Lyndon never forgot a friend. He found some money for research and kept Dr. Bushman from being fired. It was still the position of the USDA that it couldn't be done.

"I must admit, the way of doing it did sound strange,"

Dolph said. "They found that the female screwworm fly mated only one time in her life span, and if she mated with a sterile male, she would never produce. So they raised sterile flies at a plant down at Moore Air Force Base in Mission and released them out of airplanes in little boxes with lids that kicked open when they were released—so many flies per square mile. Later, they moved the plant to Mexico and it became a joint project between the two countries.

"No one knew for sure that it would work. There were no guarantees, but we believed in it. To me, this points out the value of research. People think that because an entomologist has spent 25 years of his life studying the reproductive cycle of flies, that it is an absolute waste of money. Well, it isn't."

He leaned back in his chair and thought back 20 years to when the program started. "It was a lot of fun," he said. "It did the livestock industry a lot of good, and the cost of the program was paid back to the federal government many times over."

Our visit had overextended banking hours. The lobby of the bank was dark when I asked Dolph what advice he might give to his son or grandsons.

He smiled and said, "Well, one grandson, Dolph Briscoe IV, might go into ranching just as my son, Dolph Briscoe III, has. From the time Dolph III was a little boy he wanted to be a rancher. When he was little he used to say, 'Daddy, when I grow up I want to be a working rancher like Mr. Nunnley,' instead of one like me.

Well, I've always encouraged that. He worked for Red Nunnley after he got out of school. The opportunity was great because Red was the best cowman of his generation. Chip, my son, learned a lot. He's doing a fine job, and I would recommend to my grandson that he follow in his father's footsteps."

Señor Pico 8/065
AUGUST 6, 1968
FEBRUARY 14, 1980
HERD SIRE

"Early days on the King Ranch, family life was smaller and very close, especially when Grandmother was alive. I really enjoyed the cow camps. We'd go out a month at a time and work cattle, changing horses maybe four, five, six times a day. We'd start at four in the morning and work till six that night. Those days were fantastic."

Belton Kleberg Johnson
Chaparrosa Ranch
Near La Pryor

He grew up on the King Ranch, the largest ranch in the world, with an impressive heritage: a great-grandfather of historic proportions, fine cattle, and a recognized name. He was also next in line to become the head of the place. But in keeping with the ranch tradition of bringing in new blood, the position went to a "corporate type" who was married to another descendant on the ranching family tree.

Belton Kleberg Johnson did not bask in the shade long before he had established his own 100,000-acre fiefdom south of San Antonio. He called it the Chaparrosa.

West of the dusty town of La Pryor, train tracks rumbled under the wheels of my rented car. Eight miles further the blooms of a large flowering yucca fed the air with delicious earthy smells. At the gate a green-and-white sign read CHAPARROSA RANCH.

Inside the ranch headquarters I introduced myself to an attractive receptionist at the front desk. Mr. Johnson would be with me shortly, she announced.

On a dark-panelled wall of the reception room, there was a small brass plaque under a mounted buck: "Shot and killed

simultaneously by Robert and Helen Kleberg. Cleaned by Belton Kleberg Johnson."

I went through a ribbon-filled conference room and down a hall. "B" Johnson was sitting behind a massive wooden desk. Outside the large picture window behind his austere desk was a massive grave surrounded by a steel fence and shaded by one lacy mesquite. It was the grave of Señor Pico, B's favorite bull.

"He made our reputation in the Santa Gertrudis breed, so when he died I put him close as possible," B said. B was not at all evasive when asked about leaving the family ranch.

"I was raised at Kingsville. My mother was Sarah Kleberg, Bob's youngest sister. When she was killed, Uncle Bob and my aunt adopted Bobby and myself. We were raised by them. I had every expectation of coming back and working at the ranch, and in fact I did. I worked there summers and after the service, but the facts are, when my uncle [Robert] died, the family wanted a different kind of management, more of a committee style—well, a more democratic operation. So, Jim Clements became president of the ranch, and that was fine. I had been in business for myself for a long time," B said.

"I had owned the Chaparrosa long before my uncle died, so it wasn't like I didn't have something to go to. We raised our family here, so when the decision came, I offered my stock for sale. We negotiated and they bought me out with no hard feelings."

As a child, B had watched his Uncle Bob buy land for the King Ranch. Robert Kleberg acquired properties in Argentina, Brazil, New Zealand, and Cuba. In Brazil, B watched the creation of prime pastureland on which Santa Gertrudis would thrive.

B, a visionary like his uncle, bought his own 100,000-acre ranch. It was not as large as the one he'd grown up on, but it was his. It was the perfect spot to use all he'd been taught by his uncle: "Improve it and make it work." The ranch's name, Chaparrosa, means "Brush Country," and the implied ruggedness is accurate. There were no hostile inhabitants, no rampaging herds, and smallpox had long since been wiped out. The hazards that faced his great-grandfather, Captain Richard King, no longer existed. But B faced his own challenge—another frontier for a new generation. Work began. Brush was chained, plowed, and raked, and the formidable chaparral gave way to manicured pastureland. Vegetables, row crops, and cotton were planted. B even planted Christmas trees.

But B's first love was cattle.

"Purebreds are still the flagship of our operation," B said. "We sell more purebreds at auction than any other ranch, including the King Ranch."

Fall is auction time at the Chaparrosa. Excitement crackled the air and dust flew around the runway of the airstrip as neighbors landed their helicopters. Larger planes landed on the 5,000-foot airstrip, bringing guests in from all over the state.

Lunch was served alfresco. Waiters in white coats served mountains of barbecue. Trays held high by waiters bobbed among waves of white Stetsons.

After lunch, guests gathered in the luxury barn to watch the event that brought them together. The auction moved quickly. Three hundred head of Santa Gertrudis cattle were sold in a five-hour period. John Tower and James Michener were among the 700 guests in a barn so lovely that one guest said she "wouldn't mind living in."

After the auction, guests watched the *Formado*, which was originally done in Mexico by vaqueros. Horses form in a straight line, backing up against a rope. CBS television came to the ranch to film this spectacle for their *On the Road* series. The Chaparrosa is the only place in America where the Formado is still done.

At dusk, the white tents set up for dining turned slightly pink in the afternoon sun. Under the huge canvas umbrellas, dinner tables were white-linened and decorated with baskets of flowers. Candles echoed images in crystal. A day in the country slipped into a sophisticated evening.

B's business takes him all over the world. Last year he traveled to the Far East to explore the possibility of exporting cattle. A typical week might include visits to La Puerta (his ranch near Kingsville), his office near San Antonio (main headquarters), New York for a day, or possibly the California ranch, which is located in the Carmel Valley south of San Francisco. But to B the Chaparrosa is home.

"My children, Kley, Sarah, and Cece, were raised here," B said. "I could be anywhere else in the world, but my driver's license says 'Chaparrosa.'"

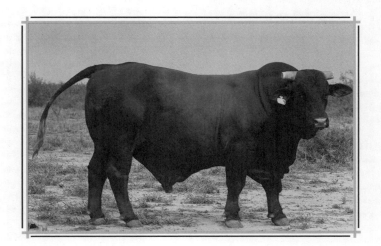

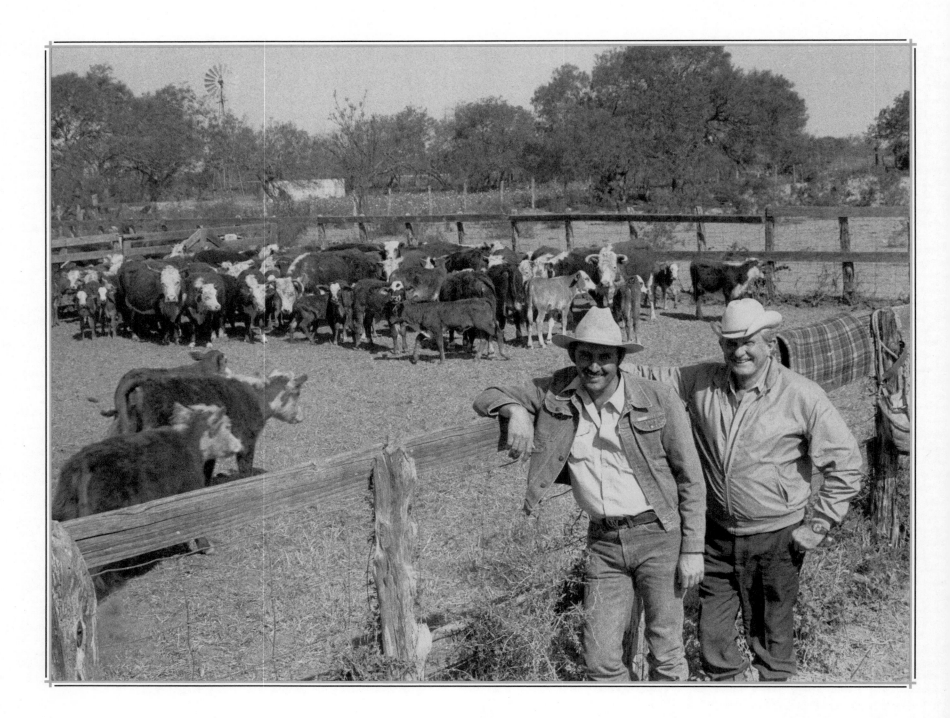

"Labor always wins."

W. W. Jones

"I used to travel with my grandfather. He was a wonderful person.
He was always worried about what was going to happen to the ranch
after the income tax and inheritance tax came in."

W. W. Jones II

"Everything down here has a thorn on it. This country is hell on
horses and women."

A. C. "Dick" Jones IV
Alta Vista Ranch
Near Zapata

uy caliente," the cook warned, pointing to a gargantuan black skillet filled with shredded beef floating in a festival of green and red chili *petines*. "What is this dish called?" I managed in feeble Spanish. The cook's eyes lit up.

"Barbacoa," he answered.

"Meat from the cow's head," said a man standing behind me.

After a morning of watching ranchhands round up and castrate baby calves on the Alta Vista Ranch 40 miles from the nearest town, lunch came not a minute too soon. Following a quick wash-up under the low-pressure trickle, it was "ladies first" through the lunch line. In the hierarchy of traditional ranch order, Dick Jones IV, owner of the ranch, was next. His foreman, Frank Graham, followed. Behind Frank were the cowboys, one in a Montana-style hat who later dipped molten-hot peppers in salt and chomped them right up to the shriveled stems without blinking a raw-eyed tear. The cooks ate last.

After lunch, Dick and I drove over to the "big house." It was here that Dick Jones IV's grandfather headquartered more

than 50 years ago. A breezy, wide-planked porch surrounded the house. Inside, patinated floors showed humps and dips of wear. The high-ceilinged living room now, as it probably always had, reflected dominating masculinity.

The Jones family springs from a pre-mesquite time of a bald and unending prairie. Predators, bandits, and Indians were prevalent in this lawless, rugged land that ran scores of pioneer families back home to a safer existence. Texas remained a place for the adaptable and the tough-spirited. The Joneses qualified.

A future generation would discover that holding on and surviving the daily trials and the whims of Mother Nature would have its rewards far beyond the dreams of the original Jones who started it all.

Captain Allan Carter Jones was born in Nacogdoches in 1830. At the time of his birth, part of Texas was still under the domain of Mexico. His parents, A. C. and Mary Jane Jones, were among the earliest settlers in East Texas.

At 22, with $2,500 that he'd earned farming, he moved to Goliad and started in the cattle business. Times were tough, and Indian raids and unstable markets caused him reverses and disappointments, but he held on and reinvested. In time, he would become the sheriff of Goliad and one of the wealthier men in the southwest part of the state.

Having already established himself financially and civically, A. C. enlisted in the Civil War and was promoted to the rank of captain. His army service was spent along the Gulf Coast and the Mexican frontier.

After the Civil War, he returned to Goliad. He moved to Bee County (Beeville) in 1871 and became the town's most active citizen. He held the office of county treasurer and, knowing that Beeville's growth would depend on them, was a liberal contributor toward securing the two railroads. In addition to ranching, he started a mercantile business. A. C. soon became known as the "father of the town."

After annexation, Texas faced yet another imperialist threat, and its leaders requested that President Polk send United States troops to defend Texas from invasion by Mexico. Texas had won its independence from Mexico at the battle of San Jacinto and claimed the Rio Grande as the natural boundary. Mexico, however, did not want the United States Army to cross the Nueces River, which it considered a boundary, and issued a proclamation ordering American troops back across the Nueces.

Under General Zachary Taylor, 1,500 men were called into action. The army departed from Corpus Christi on May 9, 1846. Mexico once again fought over the disputed boundary in an altercation known as Resaca de la Palma, at a place three miles north of Brownsville, now owned by the Yturria family. Captain A. C. Jones fought with Taylor through the final shot.

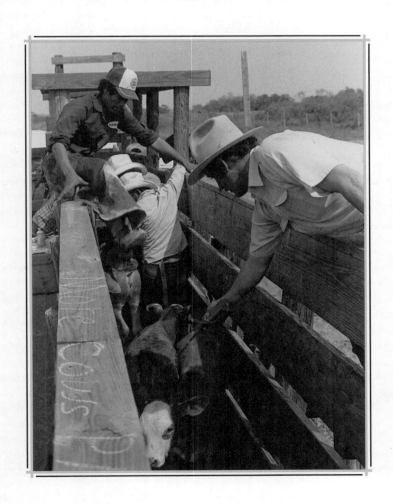

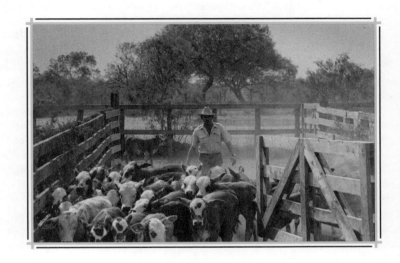

Captain Jones's son, William Whitby, followed his father's footsteps. He bought, sold, and traded cattle. After several years of success, he came to South Texas and started leasing land for ten cents an acre. The closest market was Fort Worth. His grandson Bill tells the stories of rough and tough cattle drives.

"First they'd drive the steers to the Norias division of the King Ranch," Bill explained, "which was 80 miles from Alta Vista, then ship them to Fort Worth. There were no windmills and no roads. Fever ticks were a constant threat, and consequently ranching conditions were difficult, but my grandfather was successful in hanging on."

William Whitby Jones later acquired other ranches from old Spanish land grants. His first was the San Javier Ranch from the Las Animas de Abajo grant. "My grandfather came here when this country was open frontier and held on in spite of droughts, pestilence, and disease. At 80, he was still trying to buy ranches."

Helen Harbison, another South Texas pioneer, remembers W. W. Jones and early life at Alta Vista.

"The Jones's ranch, Alta Vista, was a gathering place with its own post office. Occasionally the Texas Rangers would camp at Alta Vista looking for *tequileros* coming from the Rio Grande. It was comforting to know they were there," Harbison said.

"Weddings were festive occasions at Alta Vista. When any of the help married, Mr. Jones gave a big barbecue. I've never seen so many goats being cooked before or since. There were platters of tamales and the traditional *pan de povo*, a cinnamon-and-sugar cookie. Everyone danced on a grand white pavilion. One of the musicians who played for the dance was an old blind cowboy who played the accordion."

Helen Harbison remembers Jones as a scholarly man who had studied for the ministry. He once married a couple on the ranch. "One of his favorite sayings was, 'The Lord chastises those he loves the best,'" she quoted.

Jones's family called him "Big Daddy." His large white wicker rocker still sits on the Norman Rockwell-style front porch at Alta Vista. When "Big Daddy's" daughters were born, he planted a palm tree for each girl in honor of her birth. When each girl died, the honored palm died with her.

The great-grandson of W. W. Jones, Dick IV, is a self-disciplined, hard-working rancher who has a strong sense of what his life is about.

We pitched and throttled through the brush in his truck that smelled of old leather saddles and horses' sweat. Occasionally he stopped at a pen where his men were working cattle, got out, and helped shove a bawling cow into the back of a trailer. He returned to the truck wiping March sand out of his eyes and commented on the fact that they were short of help—a complaint made frequently by ranchers.

"It gets lonely out here 40 miles from town. There's not much for the wives to do. It was easier back in the '40s when Humble Oil Company had a camp down here—people visited, there was more to do. Now it's hard to find good help. There's an art to driving cattle. It looks easy, but it isn't," Dick said.

The Jones ranch is so old that one occasionally stumbles on ruins left by the Spaniards. "The watering system on the ranch prior to the windmill were the old hand-dug wells. They were deep and filled with caliche blocks to keep the water in. I had them fenced in," Dick said, adding that a man on horseback could fall in and both he and the horse might never be seen again.

What's a day like when Dick Jones isn't up at four working cattle or repairing windmills? "Well," said Dick, "I'll get the men lined up, make the rounds, look at some country, check windmills, then I might be back at the ranch at noon, get in the plane and fly to Corpus. I'll spend the afternoon at the office in Corpus, fly home in time to eat supper and watch the news."

★ RED NUNNLEY ★

"Red Nunnley was the best cowman in Texas. There'll never be anyone else like him."

Hon. Dolph Briscoe
Governor of Texas (1973-1979)

"Don't ever agree with me. If you do, I'll change sides."

Red Nunnley
(1907-1983)
La Paloma Ranch
Near Eagle Pass
Texas Coyote Ranch
Near Sabinal
Texas Junco Ranch
Near Encinal

ircumstances suggested that there were two men in Texas I might not see. Both cattle raisers possessed a trait of single-mindedness reaching mythic proportions. Both were raw-spirited dropouts from the twentieth century.

Tom East, the younger of the two, was the great-grandson of Captain Richard King. Although he was worth millions, he owned only one tie, and it boasted a grease spot. Tom had no use for town; he preferred the solitude of his ranch to the humdrum of Hebbron-ville. He successfully eluded me to his dying day.

The other was the redheaded, nonconforming, no-nonsense, "hit 'em up and head 'em out" Red Nunnley, who owned ranches at Eagle Pass, Sabinal, and Encinal.

Of the two, Red probably offended more people. His reputation for being cantankerous is undisputed in Texas. His refusal to vaccinate his cattle for brucellosis threatened the leadership of the Texas and Southwestern Cattle Raisers Association on more than one occasion. When the subject comes up, it's about as comfortable as removing a mesquite thorn. Red thought it was a hoax.

When Red answered the phone at his ranch in Sabinal,

his voice resonated "old-schooler." I was certain that this feisty man with his mind set in concrete would balk at the very mention of an interview—especially with a woman! I was wrong. Red feigned charm and baited the hook with politeness. He invited me to meet him at his ranch in Eagle Pass. To test my agreeability he added, "Call me in the morning...around five."

One hundred fifty miles later, after a restless night of watching the green glow of a digital clock flicking the night away in Eagle Pass, I reached for the phone. It was 4:45 a.m. In South Texas, punctuality is synonymous with trustworthiness. If you are late, you're tossed out of the credible category in a jalapeño hurry.

"Yep," Red answered, "I'll be there as soon as the fog lifts." Red would be flying in from his ranch in Sabinal. Rumor has it that he flew without a license.

The minute my car crossed the cattle guard of Red's La Paloma Ranch on the outskirts of Eagle Pass, John Driscol, his foreman, left the warmth of his truck and, in a long-legged saunter gaited in authority, came over and welcomed me to the ranch. He glanced briefly at his watch and said, "Red's not here yet. It's foggy in Sabinal."

The drone of five helicopters in the background broke the quiet of the overcast morning. "I'm going to let you ride with Larry Holt. Larry just made a television commercial for Miller Beer in Wyoming," John said.

I had come out there at the crack of dawn to visit with Red Nunnley. No one ever mentioned helicopters. It became painfully obvious that if I were to earn the respect of this cattle-man, famous for his no-nonsense ways and for having no middle gray in his personality, I would have to climb aboard this machine that looked like a bulbous, one-eyed bug lighting on the dew-covered prairie.

Where were the grand themes of cowboy life? Here instead was the invasiveness of aerodynamics—airpower replacing manpower, lacerating blades replacing lassos. No snap of a rope, whinny of a horse, jingle of a spur, not even a single "Whoa" greeted me.

I boarded the one-eyed bug and asked Larry if he had ever flown before, other than in television commercials. He laughed and said, "That's all I did in Vietnam." That out of the way, and sensing something between relief and terror, we lifted off with a riveting whomp. The other choppers rose from the horizon, breaking the morning's lethargy.

Larry spotted his first cow. "What," I thought, "if all four pilots spot the same cow at once?" I tried to concentrate on my camera, but later discovered that only three shots out of a hundred were in focus.

Larry handed me a six-shooter and asked me to load it with rat shot. "Why?" I asked.

"Well," Larry said, "if a cow gets under some heavy brush and refuses to budge, this will help him a little."

I gingerly aimed the six-shooter out the window at a stubborn cow who refused to move. Immediately the cow jumped up and joined the rest of the herd.

Red appeared in his helicopter, flying above the others and orchestrated the roundup via headsets. On the ground, cattle moved through labyrinths of pasture like small tributaries bound by brush into orderly lines of dark motion. Pilots flew semicircles around the herd, moving them toward the pens.

When we approached the pens, cowboys below covered their faces with bright-red bandanas to protect themselves from the shrapnel-like dust stirred up by the hovering choppers. When the last cow was in the pen, the men rushed to close the gates. The airborne headed for an open pasture, where we put down for lunch. When we landed, I was a basket case of gratitude.

Red got out of his helicopter wearing a headdress more like Lawrence of Arabia's than a rancher's. It was actually a hat with a large, floppy flap to protect his neck from the sun. He was warm and friendly and asked me if the ride had made me sick. Triumphantly, I said, "No."

Near a weathered mesquite corral, Red's men built a fire on which to toast their tacos. Red offered me one of the tacos while he charred his bologna sandwich to a crisp over mesquite coals. The charred sandwich didn't faze him. He chased it down with black coffee.

Red talked about the roundup. "Every cow you saw in the pasture actually thinks. They've got a lot more sense than we give them credit for. In some ways, cattle are like children. A child comes home and is not feeling well. You notice it. It's the same with a cow. Come on up to Sabinal tomorrow and I'll show you around."

At noon the next day, after another 100 miles, Red and I had lunch, which was prepared by his maid. He told me that I didn't eat enough to keep a bird alive and that he missed his wife, who had died several years ago. Then he showed me photographs taken of a roundup in 1944.

"Those were the days when we rounded up the hard way—on horseback. We had a crew of 12, plus a couple of cooks and a chuck wagon. Sometimes we'd be out in the brush for two weeks. It was rough out there, fighting that brush. Now, with helicopters, we can do the same thing in six to eight hours."

Years ago, Red bought and traded cattle in Mexico. He drove them over a long, wooden bridge that connected Villa Acuna to Del Rio. The herd crossed the swaying bridge with two state officials, one in front of the herd, the other at the rear. Both were making sure the cattle entered the United States tick-free.

The banks of the Rio Grande between the bridge and the pens were muddy. One hoof in the mud meant quarantine and a

ten-day incubation period. Red set out to solve the problem. He hauled in more than 100 truckloads of gravel and created a road so the bovines could cross mud-free and tickless.

Controversy has surrounded Red Nunnley for years over his fight against brucellosis laws and governmental decrees that he vaccinate his cattle. Red refused to do so. When a veterinarian speaking at a Cattle Raisers Association meeting in San Antonio was asked by Red if he had a test that was 100 percent accurate at verifying brucellosis, the doctor ventured off on another subject. Red asked again and again. The doctor avoided Red's question. "God-dammit, answer my question!" shouted Red. The doctor answered weakly, "No."

Red's constant energy came from his positive outlook. "Don't look back. It's where we're going to tomorrow that counts," he said. "I guess if I could master the cattle business, I'd probably quit and do something else. That's why I stay in it. Every day is different."

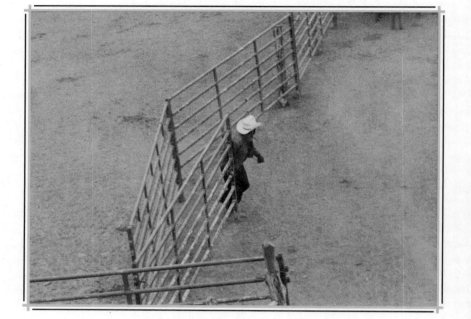

In 1983, the 76-year-old Red was hunting deer on his ranch in Encinal. He was stricken with a heart attack and died. A few years later, Creath Davis wrote a tribute to Red that Roy Coffee of Dallas presented to the Texas and Southwestern Cattle Raisers Association, along with Red's boots. The tribute ended with the line, "Red died like he wanted to, with his boots on."

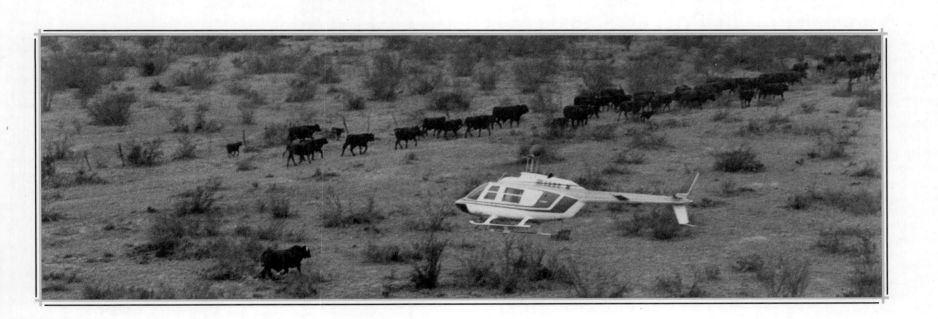

ACKNOWLEDGMENTS

Over the last ten years I have taken 24 trips to South Texas and have become richly entwined with a breed of men and women who continue to live a sustaining belief: "I may not know who I am, but I know where I come from." All of them embody a life-style of enviable proportions. While continuing to live in the tradition of their forefathers, they watch the wildness that surrounds them as it is ravaged by progress.

What are ranchers really like? They wear khaki pants—usually tucked in their boots. They love their privacy, yet they wave to every stranger they pass on the road. They are realists. They are seldom without their cowboy hats. Their daddies' daddies knew each other. Every one of them would give an arm to have "gone up the trail." And each of them has an entire chorus of yapping dogs waiting in his yard for your car to turn in the gate—which you had better close on your way out. To be with each of them is to be in the company of character. I thank them all.

I also thank Don Malouf, my precious husband, whose strength, love, and constant support has seen me through life. How important he is to me! Thanks also to our four outstanding and wonderfully special children, Blake, Carter, Spencer, and Brooke. To my friends I got by with a little help from, Jonnie Dodson and Estelle Harper of Hebbronville, I love you both. Thanks to David Farmer of De Golyer Library at Southern Methodist University, and to his wife Carol. Thanks to A. C. Greene for always being there with an answer, and to his late wife, my special friend Betty Greene. (I miss you Betty! And you too, Preston Jones.) Thanks to Bobby Muller of Laredo for helping so much. Thanks for the support from Jane Albritton, Mary Jacquline Trussel, Janis Coffee, Fran Bearden, Lou Ellen O'Kennon, David Weber, and Marsh Terry. Thanks to Luis Martín for suggesting 20 years ago that I try writing. Thanks to my summer neighbors in Santa Fe, Elizabeth Thornton, Joan Potter, Anne Atwell, Bev Hayden, Beth Miller, Fequet Hanna Duckworth, and Beaty McGrath. Thank you all for your friendship.

Dian Leatherberry Malouf

BIBLIOGRAPHY

Allhands, J. L. *Gringo Builders.* Joplin, Missouri; and Dallas, Texas: privately printed, 1931.

Allhands, J. L. *Uriah Lott: Dauntless Pioneer and Man of Vision.* San Antonio, Texas: The Naylor Company, 1949.

Broyles, William Jr. "The Last Empire." *Texas Monthly,* October 1980, p. 150.

Dobie, J. Frank. *A Vaquero of the Brush Country.* Boston, Mass.: Little, Brown and Co., 1946.

Douglas, C. L. *Cattle Kings of Texas.* Fort Worth, Texas: Branch-Smith, 1968.

Fehrenbach, T. R. *Lone Star: A History of Texas and the Texans.* Toronto, Ontario: McMillan Publishing Co., 1968.

Garcia, Clotilde P. *Captain Blas Maria de la Garza Falcón, Colonizer of South Texas.* Austin, Texas: The Jenkins Co. and San Felipe Press, 1984.

Garcia, Clotilde P. *Padre Jose Nicolas Ballí and Padre Island.* Corpus Christi, Texas: Grunwald Publishing Company, 1979.

Grimes, Roy, ed. *Three Hundred Years in Victoria County.* Austin, Texas: Nortex Press, 1985.

Hammet, A.B.J. *The Empresario: Don Martín de Leon.* Waco, Texas: Texian Press, 1973.

Hudson, Hobart. *Refugio: A Comprehensive History of Refugio County from Aboriginal Times to 1953.* Vol. I. Houston, Texas: Guardsman Publishing Co., 1953.

Hunter, J. Marvin, ed. *The Trail Drivers of Texas.* New York, N.Y.: Argosy-Antiquarian, 1963.

Jackson, Jack. *Los Mestenos: Spanish Ranching in Texas, 1721-1821.* College Station, Texas: Texas A&M University Press, 1986.

Lasater, Dale. *Falfurrias: Ed C. Lasater and the Development of South Texas.* College Station, Texas: Texas A&M University Press, 1985.

Lea, Tom. *The King Ranch.* Boston, Mass.: Little, Brown and Co., 1957.

Lehman, V. W. *Forgotten Legends: Sheep in the Rio Grande Plain of Texas.* El Paso, Texas: The Western Press, 1969.

Lott, Virgil N., and Virginia M. Fenwick. *People and Plots of the Rio Grande.* San Antonio, Texas: The Naylor Company, 1957.

Lott, Virgil N., and Mercurio Martinez. *The Kingdom of Zapata.* San Antonio, Texas: The Naylor Company, 1953.

Martin, Madeline. *More Early Southeast Texas Families.* Quanah, Texas: Nortex Press, 1978.

McMullen County History. Tilden, Texas: McMullen County History Book Committee, 1988.

Montejano, David. *Anglos and Mexicans in the Making of Texas, 1836-1986.* Austin, Texas: University of Texas Press, 1987.

Nordyke, Lewis. *Great Roundup.* New York, N.Y.: William Morrow and Co., 1955.

Peavy, John R. *Echoes from the Rio Grande.* Brownsville, Texas: Springman-King Company, 1963.

Porterfield, Bill. *A Loose Herd of Texans.* College Station, Texas: Texas A&M University Press, 1978.

Robertson, Brian. *The Wild Horse Desert.* Edinburg, Texas: New Santander Press, 1985.

Scott, Florence Johnson. *Historical Heritage of the Lower Rio Grande.* San Antonio, Texas: The Naylor Company, 1937.

Smith, Diane Solether. *The Armstrong Chronicle: A Ranching History.* San Antonio, Texas: Corona Publishing Co., 1986.

Stambaugh, J. Lee, and Lillian J. Stambaugh. *The Lower Rio Grande Valley of Texas.* San Antonio, Texas: The Naylor Company, 1954.

Tidwell, Laura Knowlton. *Dimmit County Mesquite Roots.* Vol I. Austin, Texas: Wind River Press, 1984.

Valley By-Liners. *Gift of the Rio: Story of Texas' Tropical Borderland.* Mission, Texas: Border Kingdom Press, 1975.

Valley By-Liners. *Rio Grande Roundup.* Mission, Texas: Border Kingdom Press, 1980.

Valley By-Liners. *Roots by the River.* Mission, Texas: Border Kingdom Press, 1978.

Webb, Walter Prescott, and H. Bailey Carroll, eds. *The Handbook of Texas.* Vol. I. Austin, Texas: The Texas State Historical Association, 1952.

Wilkerson, J. B. *Laredo and the Rio Grande Frontier.* Austin, Texas: Jenkins Publishing Co., 1975.

David Montejano's *Anglos and Mexicans in the Making of Texas, 1836-1986* yields new information on a neglected subject. The frailties of undocumented information frequently leave those who read history confused in biased interpretation.